IMAGES
of America

EAST ROCKAWAY

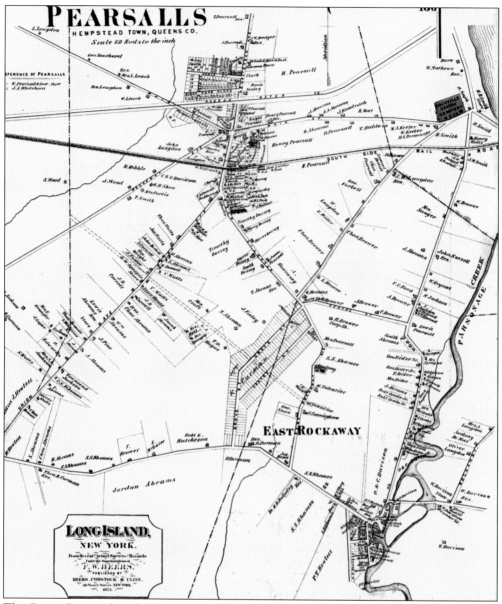

This Beers, Comstock and Cline 1873 map of East Rockaway illustrates pockets of development of southwest Queens County that subsequently became Nassau County in 1900. This was almost 200 years after the construction of the gristmill and as life in the area developed. (Courtesy of the Historical Society of East Rockaway and Lynbrook.)

On the cover: Please see page 76. (Courtesy of Gene Torborg.)

IMAGES
of America

EAST ROCKAWAY

Patricia C. Sympson, Ph.D.

ARCADIA
PUBLISHING

Published by Arcadia Publishing
Charleston SC, Chicago IL, Portsmouth NH, San Francisco CA

Printed in the United States of America

Library of Congress Control Number: 2008941302

For all general information contact Arcadia Publishing at:
Telephone 843-853-2070
Fax 843-853-0044
E-mail sales@arcadiapublishing.com
For customer service and orders:
Toll-Free 1-888-313-2665

Visit us on the Internet at www.arcadiapublishing.com

CONTENTS

ACKNOWLEDGMENTS

One does not complete a project of this magnitude without the input and assistance of many others, each of whom contributed in his or her own way. Their knowledge, photographs, talent, insight, and expertise make the book come together in the best possible way. I trust I have included all of you who made East Rockaway your own. Please accept my apologies if I have omitted you; you are exceptional. A special note of thanks is extended to Matthew Lowery for his computer expertise, willingness to share, and answers to my panicky questions whenever they came up. To Rebekah Collinsworth, my Arcadia editor, who has been patient, insightful, and kind in her direction to me, I say thank you most sincerely. My husband, Robert, deserves a special word of thanks for his extreme patience yet insistence that the history portrayed be authentic and accurate to the best of my ability. Included in my gratitude are the Historical Society of East Rockaway and Lynbrook, John Bishop, Kenneth T. Clark, Tim Chung, Mary Colway, Betsy Davison, Robert Davison, Oliver and Virginia Davison, Michael DeLury, Gregory Dengel, Jay Fader, John Felbinger, Carolyn Ferretti, Barbara Goodspeed, Barbara Gribbon, Katherine Heintz, Joseph Herbert, John Hewlett, Maryanne Hoesel, Rev. William Jablonski, Elaine Kiernan, Karen Kline, Robert Klose, Donald Krendel, Robert and Veronica Krendel, Diane Lukaitis, Stephanie Maddalone, Lucille McAssey, Margaret McKeon, Dr. Roseanne Melucci, Barbara Moore, Ellen Morrison, Rev. Richard Nilsson, James Pearson, Madeline Pearson, Dan Schmidt, Malcolm Secular, Edward Sieban, Timothy Silk, Robert L. Sympson, Mary Thorpe, Gene Torborg, Steven Torborg, and Steven Zacchia.

Dedication of this book is made to five people who made it possible: Gene Torborg, Rev. Richard Nilsson, John Bishop, Betsy Davison, and Robert L. Sympson. I also wish to extend to the young people of East Rockaway the opportunity to enjoy, preserve, and love the story and heritage of their community. To Caroline, Georgia, and John Krendel, who asked every day "Has Grandma finished her book yet?" my is wish for you all the pleasures you will have as you pursue your love of history.

INTRODUCTION

East Rockaway, a village on the south shore of Nassau County, Long Island, appears in Hempstead town records on January 5, 1665, when Abraham Smith gave Thomas Statham land including "5 acars of meadow at Neare Rockaway." It was called Near Rockaway to distinguish it from Far Rockaway. Each name was relative to its proximity to Hempstead.

In 1689, Joseph Haviland built a gristmill that brought life to Near Rockaway. The gristmill was the center of the economic, social, and cultural life for the next century and a half. It was a gathering place, as well as a purposeful gristmill and later a sawmill. Near Rockaway prospered as a seaport on Hog Island Inlet, now known as East Rockaway Inlet, from which packets carried oysters and farm produce to New York City and lumber and grain farther north. It also had a thriving oceangoing trade with Europe, but this ultimately waned, as larger ships were built that could not use the harbor at Near Rockaway.

Near Rockaway's participation in the Revolutionary War was somewhat on the periphery. Queens County, which at that time included all of what is Nassau today, housed loyalists who were determined to preserve the British presence. Business connections with England made people in the town of Hempstead reluctant to interrupt their trade. Long Island had mixed loyalties to England, but most especially on the south shore of the town, people tended to support the king. Indeed, it has been noted that in many ways the American Revolution was a civil war between loyalists and patriot Americans, in addition to being a revolution from England. The loyalists on Long Island were sincere in their convictions, dedicated in their beliefs, and ready to preserve them as were those who supported the patriot cause.

One of the most prominent Queens loyalists was Richard Hewlett, who was among the plotters in a bungled attempt in 1776 to kidnap George Washington and assassinate his chief officers. Born in 1729 in Hempstead, Hewlett later moved to Near Rockaway, which is now East Rockaway. Strong willed and arrogant, he despised what he saw as the rabble who opposed the king. Ultimately he was on the losing side. Hewlett, in the fall of 1783, at the behest of Great Britain commanded a fleet of ships that sailed for Nova Scotia, which became a haven for many loyalists. He died there in 1789. Hewlett preserved his property in Near Rockaway because he deeded it to his son Oliver, who had remained neutral during the Revolutionary War. His wife and daughter returned to Long Island after his death.

Near Rockaway prospered prior to the American Revolution. It was on the margin of the War of 1812 and even the Civil War. It was an important trading center from which to bring fish, clams, and the like to the city and up the Hudson River and to return with manure, lumber, and other merchandise. It was limited, however, in its population growth. It had a gristmill, a tavern, a dozen or so houses, and a Methodist church within its boundaries.

Near Rockaway citizens provided help in rescue operations of two famous shipwrecks, the *Bristol* and the *Mexico*, both of which occurred in the winter of 1836–1837. A lifeboat was kept in Near Rockaway at Oliver Denton's on Main Street. Denton would attempt to respond to calls for help. These aforementioned wrecks resulted in frozen bodies being taken from the water and buried at the Sandhole Cemetery on the edge of Rockville Centre, Lynbrook, and East Rockaway. Financial assistance for this came from the villagers as well at the victims themselves, from whom money was retrieved.

Near Rockaway at one time included parts of present-day East Rockaway, Lynbrook, and Oceanside. With the opening of a post office in 1869, East Rockaway came into existence. The arrival of the Long Island Rail Road drastically changed the economic thrust of East Rockaway. It brought business inland away from the harbor. An observation was made that 19th-century Near Rockaway was even at that time a commuter town. Stages brought people to the railroad station to meet the morning train for New York and returned for an evening pickup. However, it maintained the perception of sleepiness it still cherishes today, albeit times do change.

East Rockaway is still an anomaly. East Rockaway was also the place of business of a famous restaurateur, Henri Charpentier. Why has his business and notoriety always been ascribed to Lynbrook? East Rockaway is a village, a school district, a post office. But in each of these jurisdictions there is an overlapping that can create confusion.

The 20th century was kind to East Rockaway, The village was incorporated in 1900. Governance was provided by the pillars of local families who held sway in the church, fire department, local government, library, and grain, lumber, and shipping industries, which dated back 100 years. Families married families and perpetuated the line of succession through this intermarriage and primogeniture. Change was thwarted because the people of East Rockaway were content to uphold the way it was and resisted any attempts to alter the status quo, sell land, build roads, or develop the community until it was impossible to hold back the tide.

East Rockaway is today a suburban community but not necessarily only a bedroom for commuters into New York City. When the village was incorporated in 1900, the population was 969. Today the number of people living in the village is almost 11,000. Many of the people of East Rockaway are employed locally and own businesses locally. Store owners, local merchants, and professional people live in East Rockaway, raise their families, support their schools and churches, and send their children to college. The Long Island Rail Road has two train stations in East Rockaway; the Long Island bus traverses East Rockaway; and most families own at least one automobile. East Rockaway is very proud of its heritage. It is a fact that many of those who graduate from East Rockaway High School return home to East Rockaway to raise families on familiar ground. East Rockaway maintains an aura of "I was born here so I am special." That no doubt makes East Rockaway special.

One

In the Beginning

The town of Hempstead on Long Island in which East Rockaway is located is one of the oldest settled communities in the New World. The Dutch and English settled on Long Island from different directions. The Dutch settled in New Amsterdam and north upland along the Hudson River; the English came south from Connecticut in search of freedom from religious persecution even in the New World. Moreover, the English and Dutch intermingled. As the English came to Long Island, they found a place ideal for settlement due its streams, flat plains for grazing cattle and planting, and hospitable Native Americans.

East Rockaway developed along the southern plain and prospered because of its location at the mouth of Mill River and its position relative to the town of Hempstead. Joseph Haviland built a gristmill on Mill River. Its proximity to the Atlantic Ocean also assisted East Rockaway in its early growth, as residents were able to plant oysters for future sale to New York City, graze cattle, grind grist, saw lumber, and plant the roots necessary for successful growth.

The people of East Rockaway owe a debt of gratitude for such agreements granting land to the colonists. The original deed with the "Governer of Manhatans" dating from 1643 granted "land from Manhattan Bay, the bounds running from Hempstead Harbor due east to a tree adjoining to the lands of Robert Williams. Witnessed by Maanktanch Cheknow, a true copy of this is compared with the original, both being written by me." (Courtesy of the Old Grist Mill Historical Museum.)

A gristmill was built in 1689 by Joseph Haviland. This south shore area was at first valued primarily as pasture by the Hempstead community. Shortly thereafter, it was recognized that this region was accessible to coastal trading because of its deep channel. Near Rockaway would become a trading center for the less-populated south shore, and the gristmill flourished for many years and became the economic hub around which the community developed. (Drawing by John Bishop.)

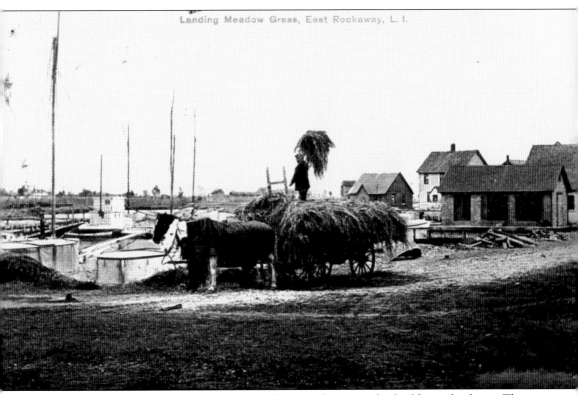

The first story recalled by Joseph Hewlett about Rockaway is the building of a fence. There was a kind of luxuriant grass that was excellent for grazing, the mainstay of the early town of Hempstead. This fence, begun in 1661 by a town resolution, extended from Near Rockaway landing as far west as Jamaica Bay. This salt hay served as feed for cattle. Cutting and transporting was controlled as of 1667 because of the importance of the crop. Salt hay was cut on land between East Rockaway and Freeport on a specific day so that everybody would have a fair share. No grass could be cut before sunrise of opening day nor could more be cut than could be transported to the mainland the same day. The undeveloped marshes, called "the meadow" by baymen and locals, still exist today but on a much smaller scale, with minimal economic benefit to the surrounding communities as well as greatly reduced habitat for flora and fauna. (Courtesy of the Historical Society of East Rockaway and Lynbrook.)

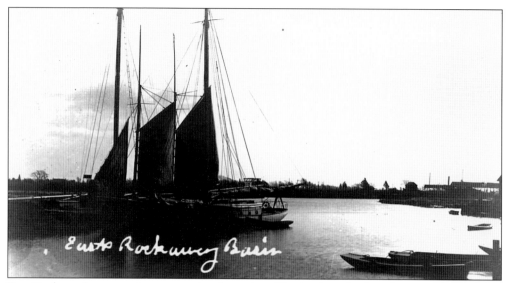

East Rockaway's topography attracted early settlers. The land was high and comparatively level; the soil was good. Parsonage Creek is the first important creek in the upland east of Jamaica Bay. It was the only village on the south side of the island where vessels drawing five feet of water could come directly inland. (Courtesy of Rev. Richard Nilsson.)

The schooner *Experiment* sailed from East Rockaway for Cadiz, Spain. Oliver Townsend Hewlett was master. She was documented in 1793 for this voyage by George Washington, president of the United States; Thomas Jefferson, secretary of state; and New York City mayor Richard Varick, when New York was the capital of the United States. East Rockaway was then noted for transoceanic and coastal shipping. (Courtesy of John Hewlett.)

Two

THE GRISTMILL

The gristmill, built in 1689 by Joseph Haviland, became the focus of life in Near Rockaway for a century and a half. The gristmill was run by various men prior to the acquisition by Robert Davison in 1818. His grandsons, Charles, Oliver, and Alexander, were ultimately deeded the mill and maintained a prosperous grist- and sawmill. In 1882, Oliver left the business, and Charles remained in charge until his death. The gristmill was the epicenter of the agricultural interests, political interests, and social interests of East Rockaway. The Davison family owned and operated the mill from 1818 to 1920. It remained in the family until 1963. The Davison family prospered, built beautiful homes, ran the mill, and left a legacy for the village to uphold. Charles used his office at the mill to have the elders meet and discuss the needs, concerns, and welfare of the people who lived in the confines of the area. This mill became a museum through the good offices of village leadership, and it opened as such in 1965.

In 1990, the mill was the victim of an arsonist flame. One of the major casualties of this fire was the ruination of an early fire department icon *Tootsie*, a hand pumper they had purchased in 1893. Fortuitously, it was restored by Amish craftsmen and returned to the Old Grist Mill Historical Museum to remain an attraction for all to see. The Old Grist Mill Historical Museum reopened to the public in 1993.

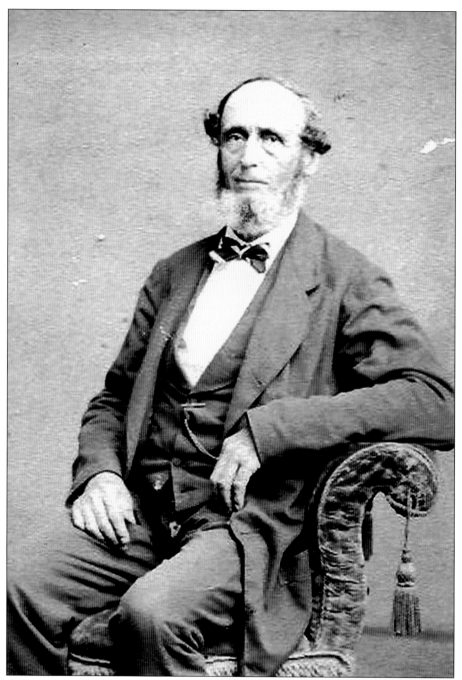

Oliver Davison, one of the three sons of Alexander who gained control of the mill, was a farmer. He was an extensive landowner also. He had worked the grist- and sawmill with Charles until they parted company. He then devoted his time and efforts to his real estate interests. He owned and controlled valuable property and received income from them. The Oliver and Charles Davison families both remained active in the commerce of East Rockaway. Each had families who participated and contributed to the growth of East Rockaway. (Courtesy of Oliver Simonson Davison.)

East Rockaway, October 12 1872

Mr. J. M. Foster

Bought of **O. & C. DAVISON,**

Dealers in

LUMBER, TIMBER, SHINGLES, MOULDINGS,

GRIST
AND
SAW-MILLS.

OLIVER DAVISON.
CHARLES DAVISON.

Brick, Lime, Lath, Guano, Grain, Flour, Feed, Nails, Etc.

Oct 7	36 sp. Plank	33	11	88		
	90 — 7 in Siding	32	28	80		
	2000 Lath	3½	7	1111		
12	7 Hemlock Bdn	24	1	68		
	12 sp. Plank	33	3	96		
	25 Plank Lath	8	2	011		

The mill was inherited at the death of their father, Alexander, in 1868 by Charles, Oliver, and Alexander, who assumed control of the enterprise for 18 months. Then Oliver and Charles purchased Alexander's share. It became the O. and C. Grist and Saw Mill, and the two brothers operated the mill until April 1, 1882, when Charles bought out the grist and lumber interests of Oliver and ran the business on his own. The saw and grist enterprise prospered as it was modernized. (Courtesy of John Bishop.)

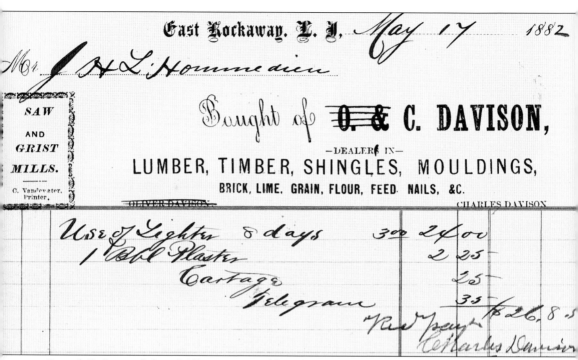

East Rockaway. L. I. *May 17* 1882

No. 1 J H L. Hommedieu

Bought of O. & C. DAVISON,

—DEALERS IN—

LUMBER, TIMBER, SHINGLES, MOULDINGS,

BRICK, LIME. GRAIN, FLOUR, FEED. NAILS, &C.

SAW AND GRIST MILLS.

O. Vandewater, Printer.

OLIVER DAVISON CHARLES DAVISON

Use of Lighter	8 days	3 00	24 00
1 Bbl Plaster			2 25
Cartage			25
Telegram			35

Rec payt $26.85

Charles Davison

O. and C. Saw and Grist Mill was operated by Oliver and Charles Davison together from 1870 to 1882. As of April 1, 1882, Charles bought out the grist and lumber interests of Oliver and ran the business on his own. The mill under Charles's leadership prospered and became a favorite meeting place for the village elders. (Courtesy of Rev. Richard Nilsson.)

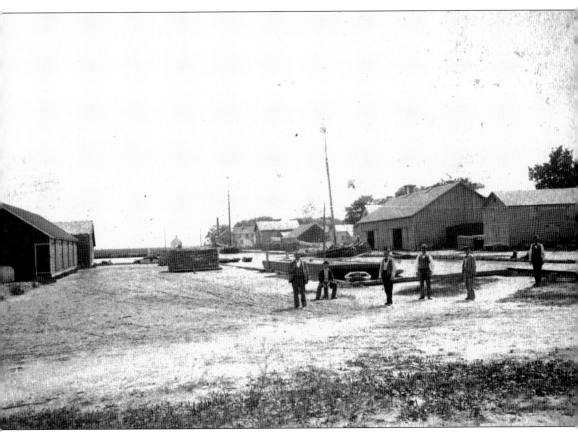

The Davison Dock and Lumber Yard in 1884 was located south of what is now Atlantic Avenue. Ships were part of a fleet of schooner ships that brought in brick from Haverstraw on trips up the Hudson River. Ships carried beach sand that was dug from sandbars at low tide in Long Beach. A channel from points east to the White Cannon was dug by the Davisons to the railroad when location of the mill was changed due to the destruction of the original dam. The flat scow in the center of the pit was used to lighten coal off ships to allow ships to proceed farther up stream. The creek was later dredged, and such scows were no longer used. Charles became a dealer in lumber, timber, shingles, and moldings and is pictured with his four sons and son-in-law. (Courtesy of Robert Davison.)

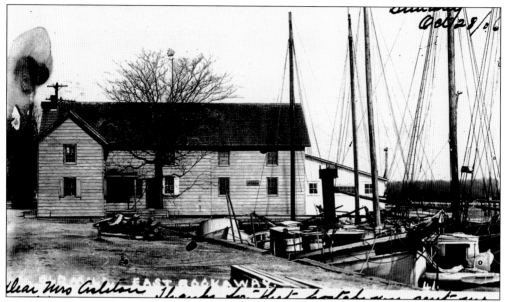

Lumber transport was important for the economic sustenance of the Davison family as well as East Rockaway. Ownership of the lumber mill remained in the Davison family for another generation. The *T. O. Smith* and the *Reaper* were important vehicles for the Davison business interests. The schooner *Reaper* was the last packet boat to enter East Rockaway Channel. The two masts were bought by the Malverne Davison Avenue School. (Courtesy of the Historical Society of East Rockaway and Lynbrook.)

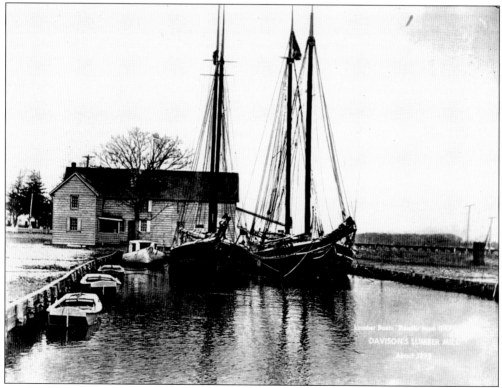

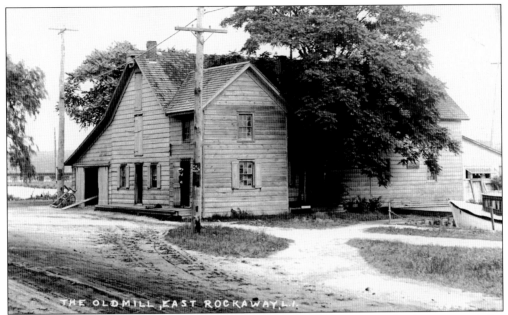

The mill is indeed old and looks to be on its last legs. The orientation for this picture is the southeast corner of Ocean and Atlantic Avenues looking north. The picture imparts sadness. While there is a smidgen of life, Robert Davison, the gentleman standing in the door, and a boat-hauling apparatus at the edge of the wagon room, gloom is pervasive. The mill's days are numbered. (Courtesy of the Historical Society of East Rockaway and Lynbrook.).

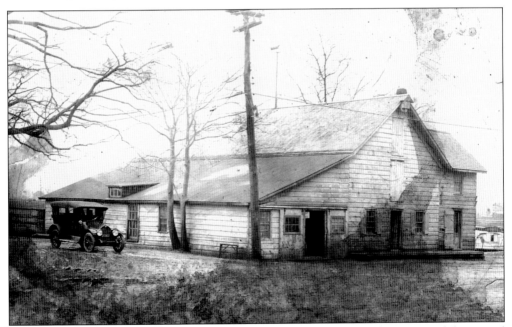

The Davison grist- and sawmill enters the 20th century in this image. Electricity and the second telephone in East Rockaway have been installed. While the weather vane is still in place, the end looms. The mill was moved to its supposed grave up Ocean Avenue opposite the Pearl Street Bridge. (Courtesy of the Historical Society of East Rockaway and Lynbrook.)

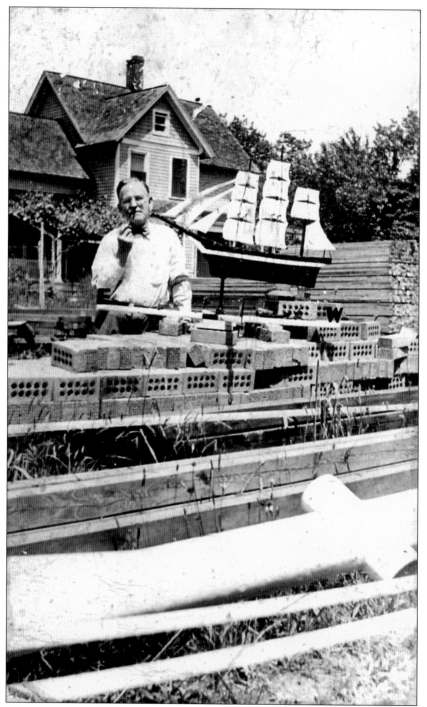

John Davison is pictured next to the now-100-year-old-plus weather vane formerly atop the mill preserved by the family. Davison's red setter every morning would go to work and stay at the mill, come home at noon with Davison, and return after lunch. Ernest Bishop said the dog kept up the daily routine even when Davison was home ill. (Courtesy of Betsy Davison.)

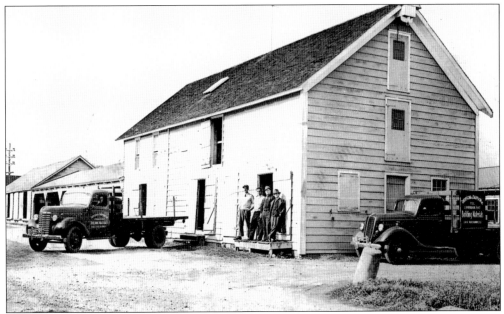

The Davison and Davison Lumber Yard was based at the gristmill. This picture includes the shed wherein a turbine was housed. Before the mill was sold, John Davison removed the eastern shed, the wagon room, and the Davison office. He kept the original piece with the first period architecture and late-19th-century addition. The two men pictured farthest to the right are Donald Davison and John Davison. (Courtesy of the Historical Society of East Rockaway and Lynbrook.)

The weather vane, which no longer sits atop the gristmill, is a valuable artifact and has been preserved by the Davison family. No doubt it has weathered the winds of a century of change at the mill and in the village. (Courtesy of Betsy Davison.)

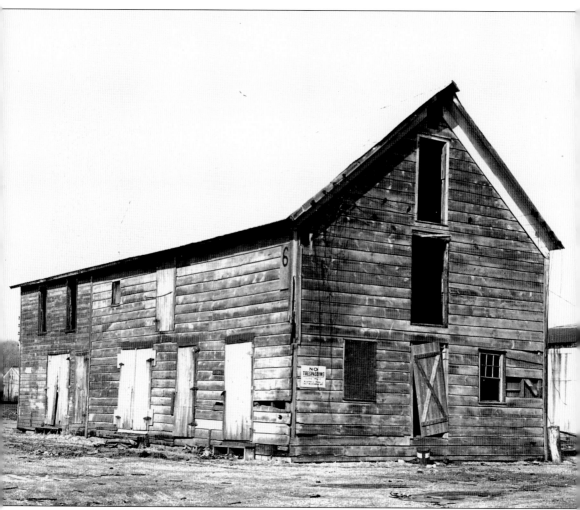

The gristmill, used as storage shed for the Atlantic and Pacific Company, fell into disrepair and was ready for demolition. East Rockaway village attorney Wesley C. Hill proposed to the village that it buy the mill and preserve it as a piece of history. The village agreed, and the mill was purchased for $1 and was scheduled to be moved to Memorial Park on Woods Avenue. (Courtesy of the Historical Society of East Rockaway and Lynbrook.)

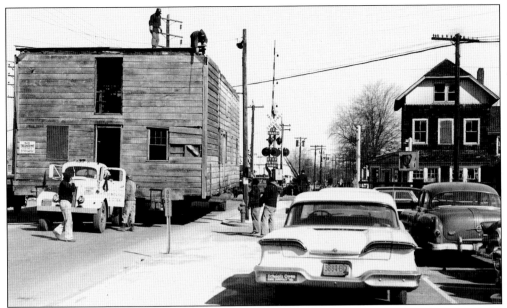

The gristmill was preserved for history as a result of industrial development in the area of the Davison lumberyard. Village attorney Wesley C. Hill and Mayor Charles M. Krull favored preservation and facilitated the acquisition and relocation of it to Memorial Park. On February 27, 1963, its roof was removed so that it could pass under telephone and electric wires, and it was placed on a house-moving trailer and pulled slowly though the village streets as people watched in awe as it was moved to its final resting place in Memorial Park. It was very common in East Rockaway to move structures. Buildings were moved down the block or across town. The mill traveled across the railroad tracks at Ocean Avenue to Atlantic Avenue, about one mile west on Atlantic Avenue, and then north on Atlantic Avenue for another three quarters of a mile. (Above, courtesy of Gene Torbor; below, courtesy of the Historical Society of East Rockaway and Lynbrook.)

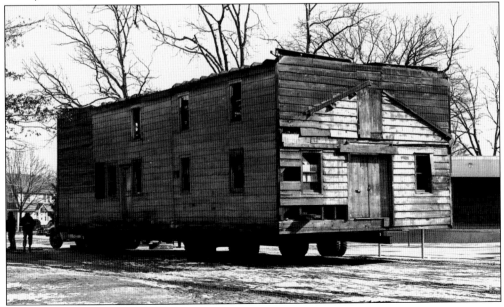

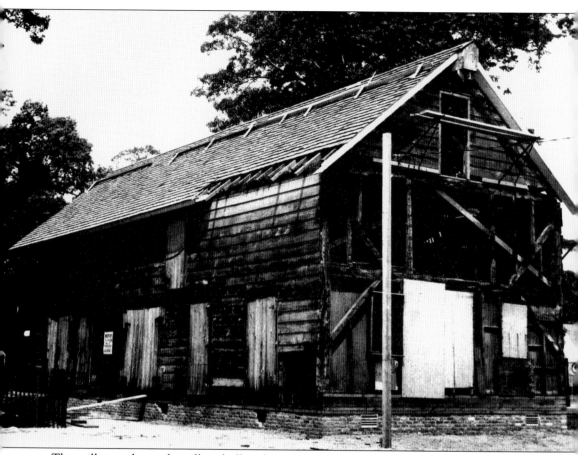

The mill moved past the village hall and was located on a brick foundation in Memorial Park facing Woods Avenue. The village and a newly formed Grist Mill Museum Committee under the leadership of architect Douglas Wilke and Mildred Roemer, chair of the committee, initiated the process of rebuilding the mill and converting it into a museum, respectively. Hard work and many hours of love in collecting and displaying the artifacts that had been collected from a number of families of the village began. On June 3, 1965, the Haviland Davison Grist Mill opened as East Rockaway's Old Grist Mill Historical Museum. (Courtesy of the Historical Society of East Rockaway and Lynbrook.)

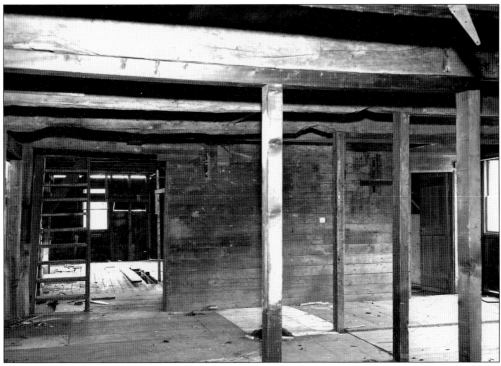

The gristmill's second, or milling, floor is facing east. Note the size of the timbers and bracing on the right as well as overhead, which points to its first period architecture. So too, the large room size and heavy beams overhead necessitated reconstruction with new four-by-four-inch posts to support the third or top floor. The steps to the third floor were moved forward about 10 feet in rebuilding. (Courtesy of Gene Torborg.)

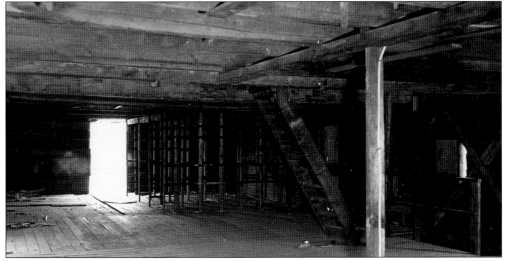

The gristmill was restored into a museum by East Rockaway. This view is from the first floor looking west. The steps are to the second floor (the milling floor), and the room beyond is the mill extension added between 1869 and 1889. In the foreground, the main section of the mill with the first period architecture is supported with modern four-by-four-inch posts. (Courtesy of Gene Torborg.)

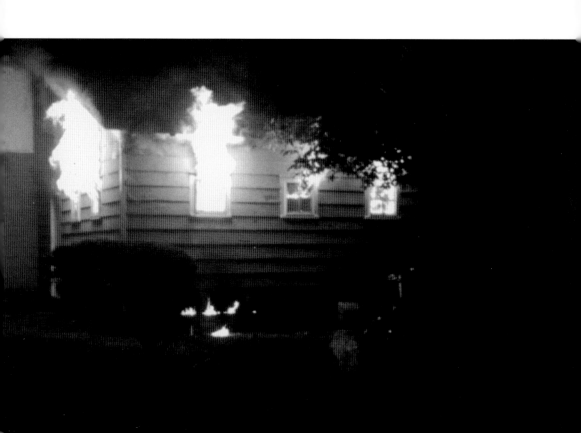

The Old Grist Mill Historical Museum was set ablaze on August 12, 1990. The fire was set in the middle of the night. The fire room was destroyed and part of the roof damaged. This was arson, and to this day, those responsible have not been apprehended. Antique fire equipment, horns, trophies, and valuable historical donations, many made by firemen, were lost and will always be a missing part of the museum. The Gleason and Bailey crane-neck pumper was badly burned. The mill itself was damaged, and the museum had to be closed for several years. It was restored over a period of three years and was reopened to the public in 1993. (Courtesy of Steven Torborg.)

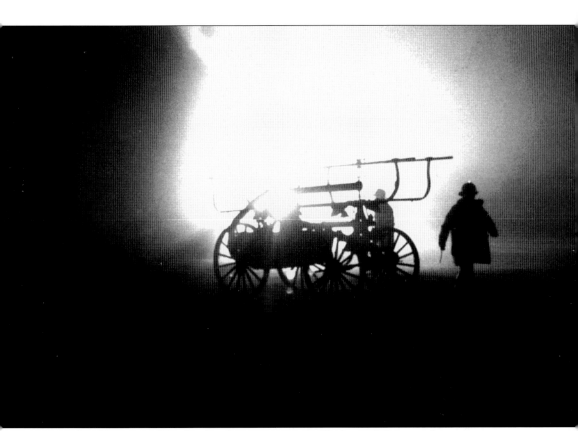

Tootsie, the Gleason and Bailey hand pumper, was badly burned. It was taken to experts in the Pennsylvania Amish countryside who were able to rebuild it. It was paid for by the East Rockaway Fire Exempts, a benevolent organization within the fire department, which owns the *Tootsie*. Refurbishment took two and one half years. It is now again displayed in the fire room of the Old Grist Mill Historical Museum. (Courtesy of Steven Torborg.)

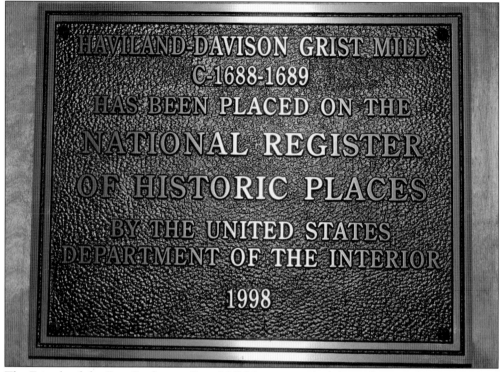

The Friends of the East Rockaway Grist Mill Museum applied for and received recognition of the Haviland-Davison Grist Mill as a historic landmark, sometimes called its "crown jewel." It was placed on the National Register of Historic Places on April 21, 1998. The preservation of the mill was based on its first period architecture. The mill was of great economic importance as a center of milling for the entire "swampe of the Rockaway peninsula." (Photograph by Donald Krendel.)

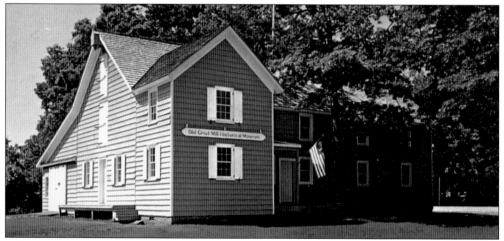

The Haviland Grist Mill, built in 1689, has been a symbol of the perseverance of the people of East Rockaway. It is a reminder of the farming days of the south shore of Long Island, the seafaring days, and the seat of power and politics. It is associated with every aspect of the development and growth of East Rockaway and is an integral part of its history. (Courtesy of Rev. Richard Nilsson.)

Three

THE FIRE DEPARTMENT

Priorities rule in the beginning when people decide to live together. Beautiful wooden homes were built, and it became obvious that a fire department was needed to protect the citizens living in the community. The village elders joined together in 1893 to incorporate a fire department. These men purchased fire equipment to be used in case of fire. The Gleason Bailey crane-neck hand pumper, which they had bought, was drawn literally by the men who would pull it to a fire. They would then pump water from a local well to fight the fire. Early on the men would meet in Charles Davison's mill office. There they were able to make plans for a firehouse, acquire the land on Main Street, and in time build their firehouse. The fire department grew. Today, as at its inception, it is an integral part of village life. Men and women now participate and perform all the functions of emergency response, firefighting, rescue operation, and disaster relief as needed in East Rockaway.

On December 8, 1893, the new company ordered a Gleason and Bailey hand engine costing $600. While awaiting delivery, the members met every Saturday evening at Davison's mill to drill. On February 20, 1894, a special meeting was called to welcome the new engine, which was delivered free of charge by the Long Island Rail Road and paraded through the streets. This is the only picture of *Tootsie* being horse drawn. (Courtesy of Steven Torborg.)

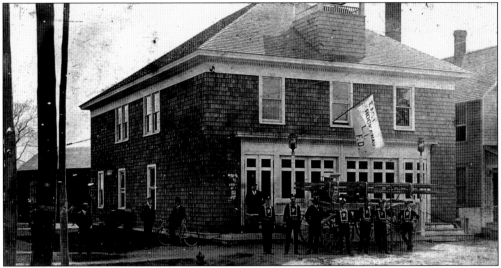

This 1895 picture of the Main Street firehouse excludes the bell tower but does include a group of early firemen in front of the Gleason and Bailey fire truck *Tootsie*. This picture has the gentleman as well as his bicycle. (Courtesy of Gene Torborg.)

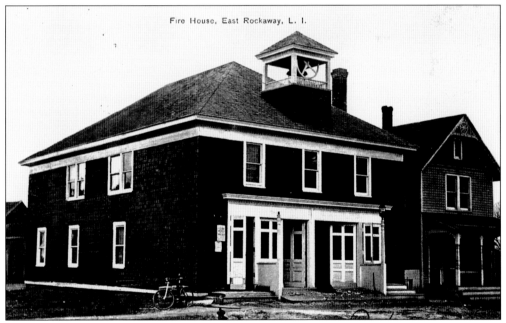

The Main Street firehouse was completed in 1902 to house the pumper and wagon purchased to carry hose, ladders, and hooks. It is pictured next to the Neu Barber Shop. Edward T. Neu was one of those who incorporated the fire department. In the cupola is the fire bell that replaced the railroad rim to summon firefighters. It appears that a dog is sitting in the doorway of the firehouse. In 1932, this building was built over the structure standing. In the process, it was erected over the bell tower that is still inside the Main Street firehouse, albeit hidden. (Courtesy of Gene Torborg.)

These are relics of East Rockaway's first alarm systems. A locomotive ring was to be rung to report a fire. Someone would run up and pound at the ring. Later a bell, located atop the Main Street firehouse, was rung to summon the men to fight a fire. It was the clarion call for many years. In 1910, Walter Southard presented to the village a fire siren, which stood the village in good stead until it later purchased an alarm system in 1922 for $4,500. Alarms were to be installed at Rhame and Baiseley Avenues, Scranton Avenue between Grant and Carman Avenues, Grant Avenue four or five poles north of Main Street, Atlantic Avenue, Davison Avenue, and Wilson Street. (Left, photograph by Donald Krendel; below, courtesy of East Rockaway Village.)

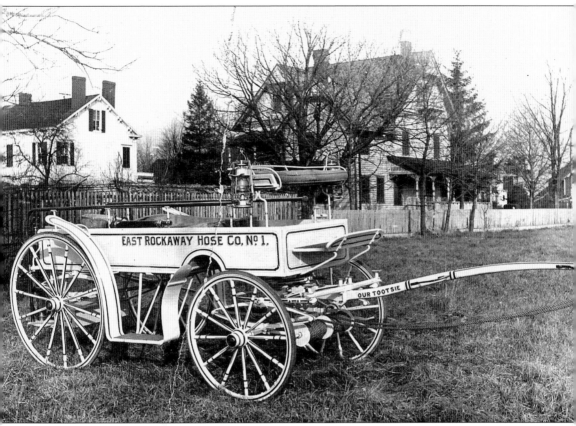

Liberty Hose Company No. 1 was formed in 1908 to provide fire protection for the north side of the village. In 1910, it bought a hand-drawn hose cart from a blacksmith shop for $65 and then purchased a barn on Grant Avenue to hold the wagon. This hose wagon is noted as "Our Tootsie." (Courtesy of Gene Torborg.)

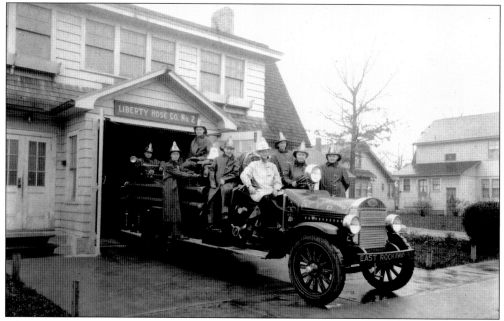

Liberty Hose Company No. 2 had an equally altruistic reason for its beginning. George Trigg started this company to help protect the residents on the north side of the railroad tracks. Trains stopped at the Centre Avenue Station or East Rockaway, both of which have ground-level tracks that would preclude protection if needed. The Clark family donated the site, and each of the firemen put up $500 for the house. The village bought the company a Model T Ford truck that stored chemical extinguishers. This company was nicknamed "the Silkstocking Boys" because their original members worked in the city and could only answer night fire calls. Liberty Hose Company No. 2 also sustained the only loss of a fireman, Robert Pryor, in the line of duty in 1970. At the time, this fatality was the first in 75 years of existence. (Courtesy of John Felbinger.)

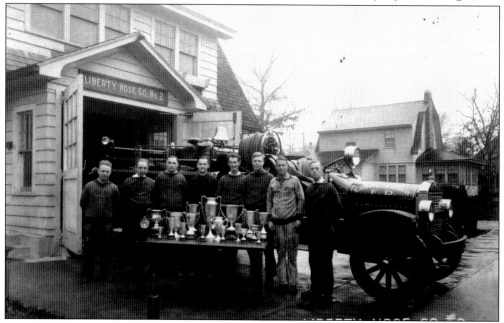

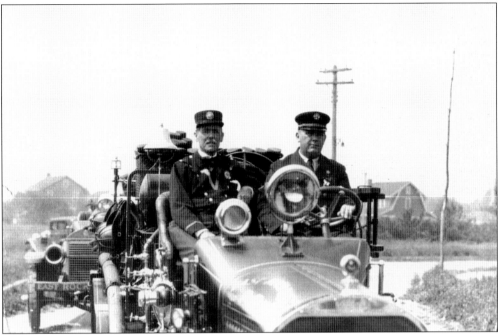

In 1926, Chief Henry Torborg Jr. is shown driving Oliver Hewlett, one of the founders of the East Rockaway Fire Department, in a 1917 Mack truck. Hewlett had also been one of the persons involved in the incorporation of the village of East Rockaway. The love of the fire department is endemic in the village of East Rockaway and is handed down from generation to generation. (Courtesy of Gene Torborg.)

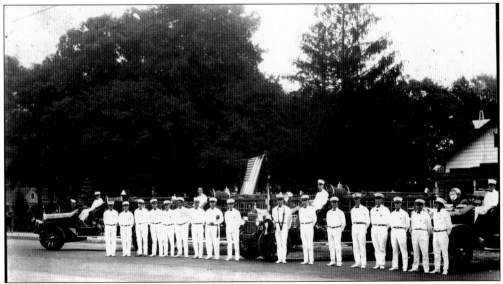

The East Rockaway Fire Department is pictured in 1925 standing in front of the village hall. It consists of three engine companies and four trucks. At that time, fire uniforms were white, later to be replaced with blue shirts to be replaced with the current uniforms of white shirts and navy suits. Chief Henry Torborg Jr. is pictured holding a trophy. He is the eighth man from the left. (Courtesy of Gene Torborg.)

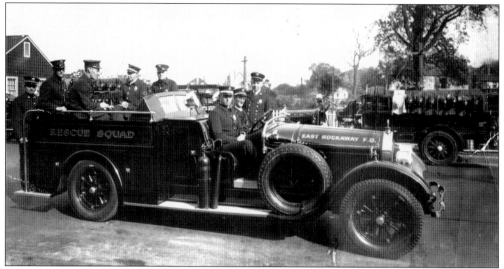

The original emergency squad was formed in 1930 to attend to firemen injured at fires. Charles A. Peter bought an old hearse and converted it into an ambulance. In 1936, a rescue emergency relief squad was created to attend to and provide assistance to the civilian population. In 1990, a fire medic program was instituted and fine-tuned wherein one was only a fire medic even though the original purpose of joining the department was to be an active firefighter. (Courtesy of Gene Torborg.)

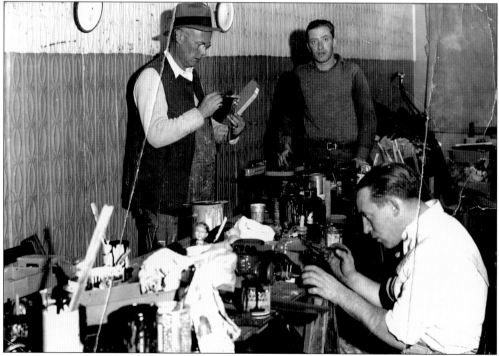

From left to right, Clarence Terry Sr., Ralph "Red" Perrin, and James Formont work diligently to repair and paint toys and dolls for needy children. This workshop in the firehouse illustrates their commitment. The fire department combines community efforts along with firefighting duties. (Courtesy of Gene Torborg.)

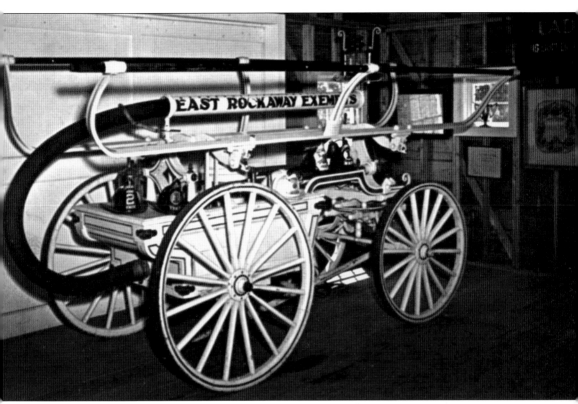

Tootsie was as good as new when the Amish restoration was completed. The cost to the East Rockaway Fire Exempts was $20,000. *Tootsie* was returned to the fire room at the Old Grist Mill Historical Museum after it too had been rebuilt. The fire department takes *Tootsie* to parades and exhibitions. It is a favorite of schoolchildren who visit the museum and hear the story of its glory days and the tragedy of the fire. (Courtesy of Steven Torborg.)

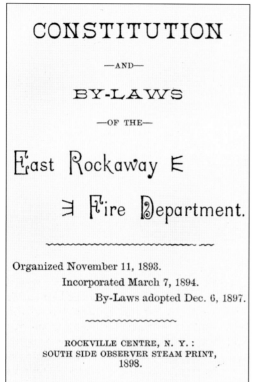

CONSTITUTION

—AND—

BY-LAWS

—OF THE—

East Rockaway Fire Department.

~~~~~~~~~~

Organized November 11, 1893.

Incorporated March 7, 1894.

By-Laws adopted Dec. 6, 1897.

~~~~~~~~~~

ROCKVILLE CENTRE, N. Y. :

SOUTH SIDE OBSERVER STEAM PRINT,

1898.

The East Rockaway Fire Department predates village government. In 1893, 27 citizens banded together to form a fire department. Henry Floyd Johnson was elected as chief foreman. They wrote and approved a constitution to begin the fire department that became an institution within the village. These men continued to play a vigorous and influential role in village life. All communities rely on a core of individuals who are informed, willing to share their knowledge, and put forth the effort to bring change and development to that community. This was true in East Rockaway. The same men held sway in all corners of village life. (Courtesy of Gene Torborg.)

Incorporators.

Henry F. Johnson,
Bernard Molitor,
Charles Davison,
Oliver T. Hewlett,
Alexander Davison,
Daniel DeMott,
George H. Schiffmacher,
George B. Simonson,
H. I. Clarke,
Hollet Pearsall,
Edward T. Neu,
Joseph Burling,
H. C. Davison,
Elijah Terrell,
S. S. Rhame, Jr.

Committee on By-Laws.

Henry F. Johnson,
Joseph Burling,
Oliver T. Hewlett,
Daniel DeMott,
Herbert C. Davison,
Bernard Molitor.

Four

THE GOVERNMENT

Government evolves from the need to protect the people who live within confines of a special locality. After the fire department was incorporated, many of the same men assumed leadership of the formation of a government for East Rockaway. One of the principal reasons for this endeavor was to be certain the taxes were held in check. The village men were afraid that outside authority would permit taxes to be levied on them, and they would forever cede control of their destiny. Some of the village fathers were well traveled and well educated, as was expected of their family class. They sought to be able to maintain the integrity of their community without undue influence from outside sources and undue reason for any taxation of which they themselves did not levy. The village maintained minimal roads and few expenses other than the expense entailed with the fire department. As the 20th century dawned, East Rockaway was incorporated and the elders met in the Davison office or at the new firehouse to discuss their plans and ideas for the future.

East Rockaway had one of the first Boy Scout Troops. It also established its own police department and subsequently an auxiliary police. It had an American Legion and a Veterans of Foreign Wars group. Moreover, a number of its female citizens were very active suffragettes.

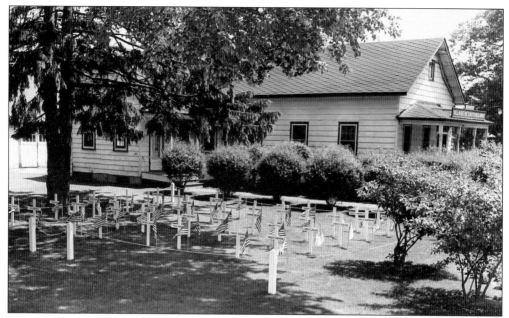

Memorial Park had been planned when the village in 1915 authorized Delamater S. Denton Jr. to survey land adjacent to the village hall. Beginning at the intersection formed by Atlantic Avenue and the southerly line of Woods Avenue and within land owned by School District No. 19, the village outlined its boundaries for Memorial Park. Prior to this, the village commemorated those who served as noted above. (Courtesy of Gene Torborg.)

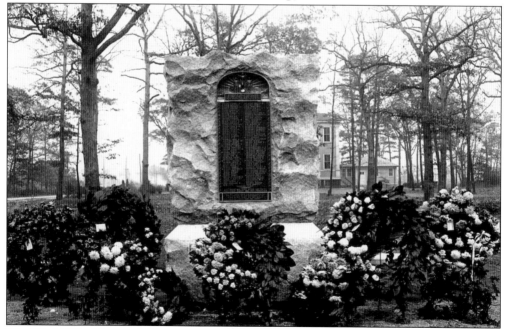

The World War Memorial Monument was "Dedicated to the Citizens of East Rockaway to the Boys Who Answered the Call of Their Country to Service in Its Military and Naval Forces in the World War." The ceremony took place in front of the village hall and was presided over by village officials and friends and relatives of war veterans. (Courtesy of Gene Torborg.)

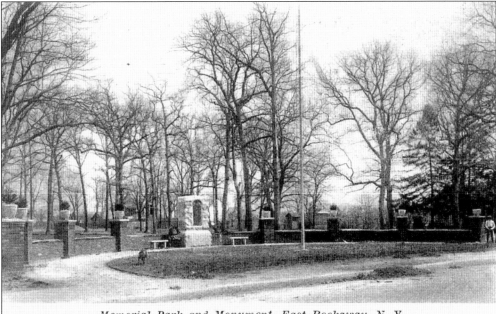

Memorial Park and Monument, East Rockaway, N. Y.

Om March 5, 1919, a proposition was submitted by the Village of East Rockaway to purchase land for a public park to be known as "East Rockaway at a price not exceeding five thousand dollars ($5000) which sum shall be the maximum amount to be paid. That amount is to be levied upon the property of said village in the year 1919." The name Memorial Park was crossed out in the original resolution and in the official village records with no elaboration. (Courtesy of Gene Torborg.)

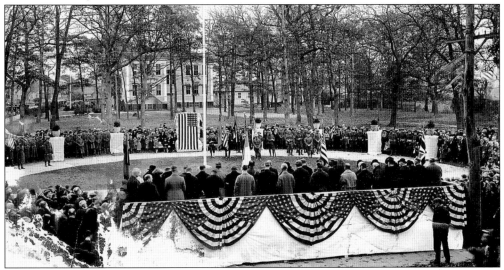

After the armistice concluded at the 11th hour of the 11th day of the 11th month of 1918, veterans were honored with remembrance ceremonies each year. Subsequent to this, there have been memorials established in the park for the veterans of World War II, the Korean War, the Vietnam War, and the Persian Gulf War who served from East Rockaway. Also within the park, a cenotaph has been erected commemorating the victims of the terrorist attacks of September 11, 2001. (Courtesy of Gene Torborg.)

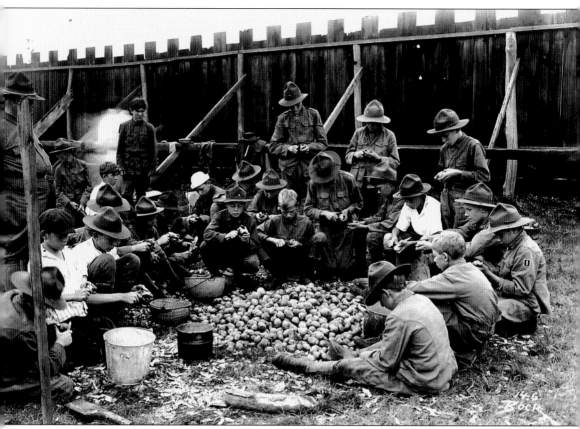

Boy Scout Troop 1, sponsored by Bethany Church, was chartered in East Rockaway in 1914. Charles Curtis was scoutmaster, and Matthew Kuckens and Russell Davison were assistant scoutmasters. From 1917 to 1919, Scouts sold Liberty Bonds and war stamps. After the armistice, the world changed for the Scouts, and Troop 1 lapsed until Troop 50 was started in 1926. The above picture is an encampment in Mineola in 1917. (Courtesy of Gene Torborg.)

The American Legion chartered in East Rockaway in 1932 began here. This building later became the White Cannon Inn, not to be confused with the White Cannon Hotel. In 1936, the American Legion moved to the Box Mansion on Davison Plaza. In 1943, its new quarters on Main Street were in Sam Rhame's daughter Carrie's house. Previously, during the Depression, her house had been sold and made into a bar, as were many of the old homes. (Courtesy of Gene Torborg.)

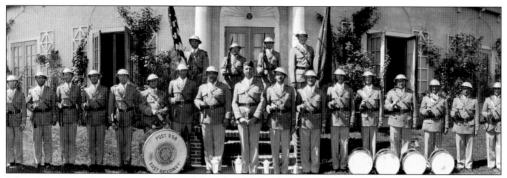

The American Legion was formed by the United States Congress as a wartime veterans organization. It was founded in 1919 by veterans returning from Europe after World War I. It is a patriotic and mutual help organization assisting not only veterans but also their families. The American Legion was instrumental in creating the U.S. Veterans Bureau, a forerunner of the Department of Veterans Affairs. The picture above, taken in front of the Box Mansion on Davison Plaza, is of those men from East Rockaway who served during World War I. The 1940 picture below is that of the sons of the men who are shown as the veterans of World War I. (Courtesy of American Legion Post 958.)

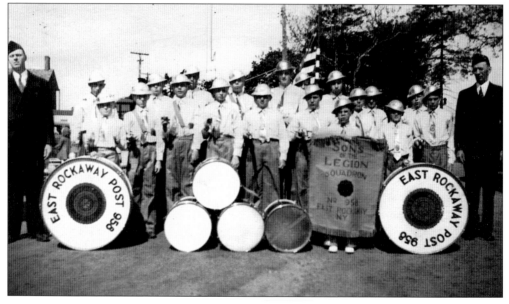

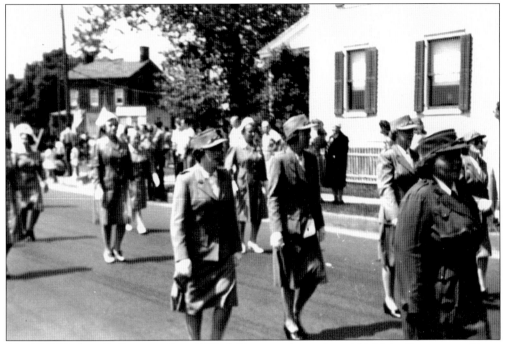

The VFW Robert F. Garrison Post 3550 clubhouse is located on 164 Main Street, near Grant Avenue, East Rockaway. The clubhouse was acquired through the enterprise of the women's auxiliary and remained in the auxiliary's possession until free of debt. The original cost was $3,000. The building is a seven-room bungalow fronting Main Street and only two blocks west of Atlantic Avenue, both main thoroughfares in the village. Today the veterans share a clubhouse with the Knights of Columbus. Both organizations are very active within the village and have a mutual membership. (Above, courtesy of the Veterans of Foreign Wars Post 3550; below, photograph by Joseph Herbert.)

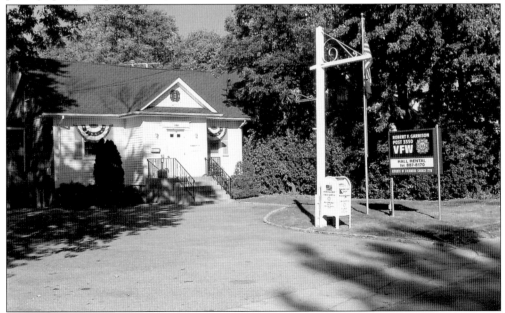

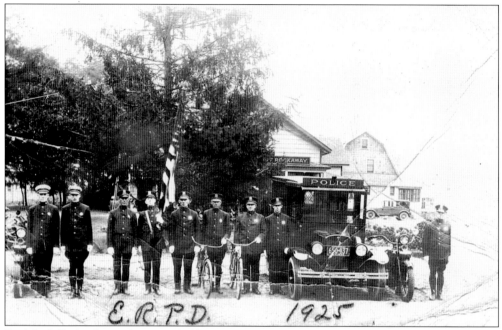

Fred Bedell, the first policeman, held prisoners in the firehouse for deliverance to the county police. The East Rockaway Police Department in 1925 appears well equipped. It had a paddy wagon, motorcycles, bicycles, and foot patrols. In January 1939, the village disbanded the Blue Coats, and they became part of the Nassau County Police. (Courtesy of Gene Torborg.)

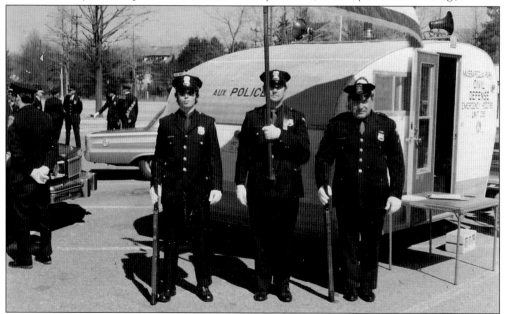

The auxiliary police were formed to supplement the regular police of the community. The auxiliary police are unpaid, part-time volunteers. They are authorized to act as peace officers who provide many and varied services. Traffic control, crime prevention, supervision of neighborhood events, community security, and emergency crisis leaders are but a few of the roles that the auxiliary police assume. (Courtesy of Diane Lukaitis.)

Ordinance No. 49, effective August 28, 1924, reflects the state of motoring in the first decades of the 20th century. Driving was to be cautious and vigilant; speed sensible; and motorists careful not to injure property and limbs of others. The tenor of modern law is concise and succinct—speed, ticket, points, suspension. The picture below illustrates life in a more pristine era. (Right, courtesy of East Rockaway Village; below, courtesy of Rev. Richard Nilsson.)

ORDINANCE NO. 49

Sec. 1 Every person operating a motor vehicle on public streets of the Village of East Rockaway shall drive the same in a careful and prudent way and at a rate of speed so as not to injure the property of another or the life and limb of any person and no person shall operate a motor vehicle on the public streets at a rate of speed greater than one mile in 3 minutes. It is hereby further enacted and ordained with the maintenance of a greater speed of 1/8 of a mile to be presumptive evidence of driving at a rate of speed which is not careful and prudent.

Sec. 2 Violation of any of the provisions of this ordinance or any part thereof shall be a misdemeanor punishable by a fine not exceeding one hundred ($100) dollars for the use of the village or by imprisonment for not exceeding thirty (30) days or both such fine and imprisonment.

Sec 3.This ordinance shall take effect August 28, 1924.

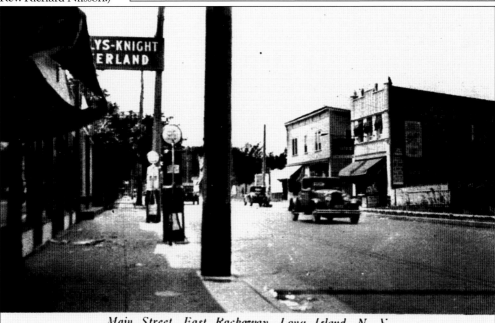

Main Street, East Rockaway, Long Island, N. Y.

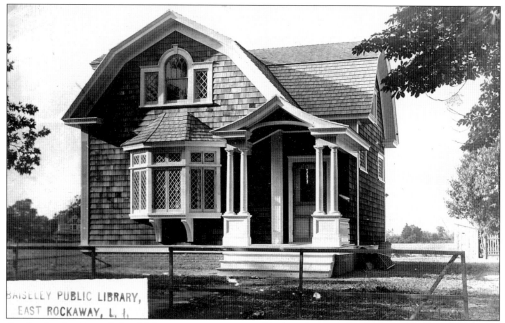

BAISELEY PUBLIC LIBRARY,
EAST ROCKAWAY, L. I.

At the beginning of the 20th century, a group of ladies from East Rockaway's oldest families, Mrs. Oliver Denton, Mrs. Robert Davison, Amelia and Irene Davison, and Mary Baiseley, began swapping books among themselves. Later they expanded the exchange and housed it in the post office at Oliver Hewlett's store. In 1906, Mrs. Russell Sage built the library and named it for her friend Mary Baiseley. It ultimately became the East Rockaway Free Library. There is some confusion about the spelling of *Baisley* as it is noted here. It has evolved over the last 50 years to *Baiseley*. (Courtesy of the Historical Society of East Rockaway and Lynbrook,)

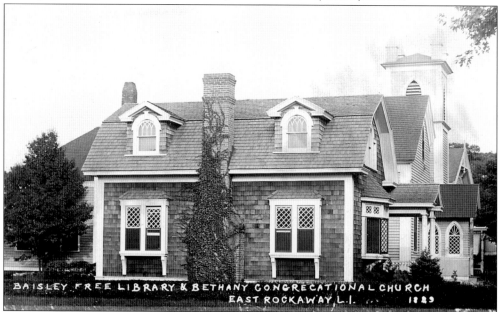

BAISLEY FREE LIBRARY & BETHANY CONGRECATIONAL CHURCH
EAST ROCKAWAY, L.I. 1889

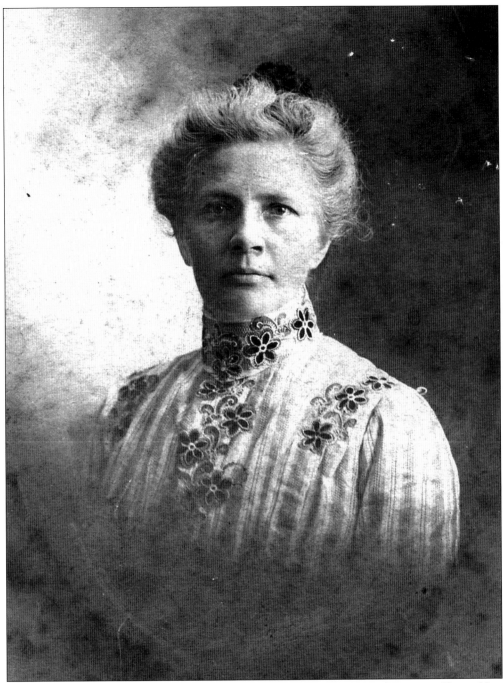

Amelia Davison was an ardent campaigner for women's suffrage, as were her sisters. She and her sisters, Irene and Susan Davison, organized bands of suffragists on Long Island. Amelia had the good fortune to live long enough to enjoy the vote for which she worked so hard. She died in 1937. She also was one of the founders of the Baiseley Free Library, one of the first free libraries in Nassau County. (Courtesy of Oliver Simonson Davison.)

PRESIDENTS

1900-1901	Henry Floyd Johnson
1901-1902	Richard Carman
1902-1908	Tredwell Abrams
1908-1910	Dennis Shane
1910-1911	Henry F. Johnson
1911-1912	Delamater S. Denton
1912-1913	Dennis Shane
1913-1917	William F. Strong
1917-1923	Walter E. Johnson
1923-1926	James F. Reynolds
1926-1927	Frank W. Donnelly

MAYORS

1927-1929	Frank W. Donnelly
1929-1933	Ossian E. Weig
1933-1937	Alanson Abrams
1937-1954	Edward F. Talfor
1954-1959	Arthur A. Schratwieser
1959-1967	Charles M. Krull
1967-1970	Winifred M. Berg
1970-1977	Arnold White
1977-1987	Theodore S. Reinhard
1987-1995	Irving F. Shaw
1995-2003	Charles H. Formont
2003-2007	James F. Carrigan
2007-	Edward Sieban

This list of government officials is interesting for several reasons. It has been said that the two H. F. Johnsons are the same person. They are not. Henry Floyd Johnson died in office, and the trustees appointed Oliver Davison as president. Davison declined, and Richard Carman was selected. The second Henry F. Johnson was controversial because at one time it was believed he did not live in the village. The title of president and mayor passed wordlessly. Frank D. Donnelly became mayor without a mention of his being one and the same president the month before. Term limits were set in place after Mayor Charles M. Krull and removed after Mayor James F. Carrigan. (Courtesy of East Rockaway Village Records.)

Five

THE EDUCATIONAL INSTITUTIONS

East Rockaway School District No. 19 is the school system for many of the children who live in East Rockaway. East Rockaway had a school at the time of the American Revolution. That did not mean that every child attended, but there was a school. In the latter half of the 19th century, schooling became a little more important. The Atlantic Avenue School, also known as the Little School in the Woods, and Woods Avenue School provided elementary educations to residents. However, older youngsters had to be sent to the neighboring communities of Lynbrook or Rockville Centre because East Rockaway did not have a high school. But of course growth occurred, and additional elementary schools were necessary and had to be built. Then the high school was built during the Great Depression. East Rockaway is somewhat unusual because the nonelevated Long Island Rail Road runs through the village so that not only did schools have to be built on both sides of the tracks, but the fire department had to also develop on both sides. Another interesting fact is that East Rockaway village extends into the Lynbrook School District No. 20, so two of Lynbrook's schools are actually built in the village of East Rockaway. St. Raymond's Parochial School, as well, was built to provide education for a growing Roman Catholic population.

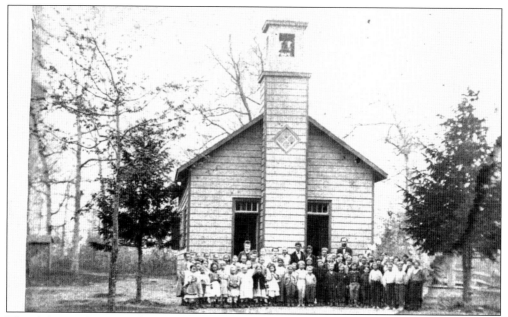

The Atlantic Avenue School succeeded the pre–Civil War school. It was built in 1859 and preceded the Woods Avenue School. It had been moved a short distance from its original site and is now used as the village hall. This photograph was taken in the early 1870s and is old and water-stained, but it reads, "Mrs. Robert Davison 34 Ocean Avenue East Rockaway." (Courtesy of Robert Davison.)

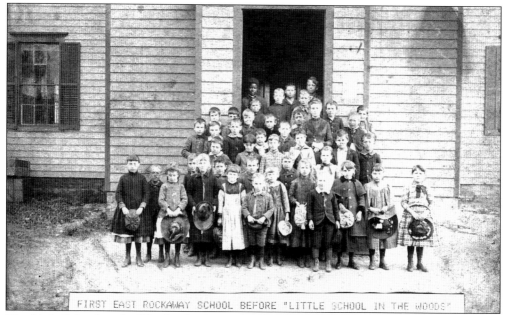

FIRST EAST ROCKAWAY SCHOOL BEFORE "LITTLE SCHOOL IN THE WOODS"

The Little School in the Woods, also known as the Atlantic Avenue School, was a two-room schoolhouse. The African American girl in the picture worked for Oliver Denton. She was buried in a Denton plot at Rockville Cemetery. Her stone had been seen by Mildred Roemer in the 1930s but disappeared when plots were moved or resold. (Courtesy of the Old Grist Mill Historical Museum.)

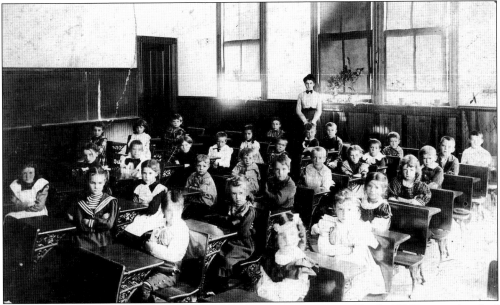

East Rockaway Dec 5/87

Received of Peter T. Hewlett
Est for school tax $18.18

C. H. Mott
School collector
List No. 19

Peter Hewlett's tax receipt was a small lined piece of paper. Taxes were an important issue to the several large landowners and wealthy persons living in East Rockaway. Incorporation of the village government was done to maintain control over taxes and spending. (Courtesy of John Hewlett.)

Edith White, Fred Mott, Howard Mott, Elsie White, May Donovan, Charles W. Davison (marked with an X), "Bertie" Burling, and "Filthier" Smith are seen in this photograph. The Woods Avenue School was built in 1898. In 1908 to 1912, the state education department abolished the high school for lack of enrollment. Students then had to travel to Rockville Centre or Lynbrook, and their tuition was paid by the Village of East Rockaway. Student ringing of the bell three times a day was essential to East Rockaway in the early 20th century. (Courtesy of Gene Torborg.)

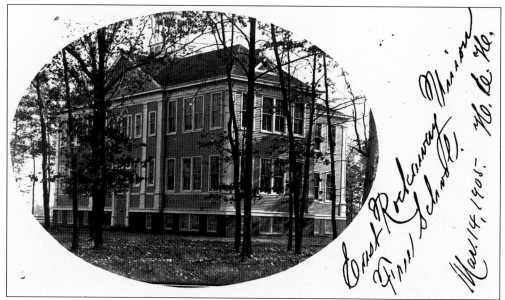

The Woods Avenue School had strict teachers and good discipline. It was not uncommon to have a whack or two freely given to miscreants. Due to a recent law making school attendance mandatory until age 16, many pupils who were 14 or 15 and who had never been to school were in the second or third grade. (Courtesy of Gene Torborg.)

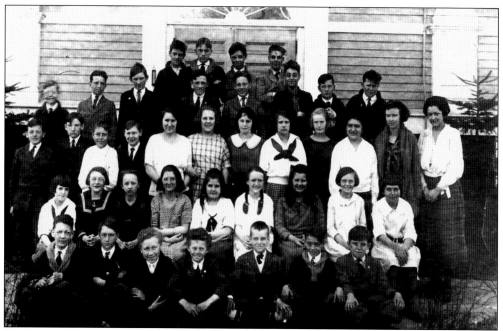

Here is an image of an eighth-grade graduation. Those identified are Brad White, Austin Weatherhill. Ernie Bishop, Harry Stocker, Herman Thompson, Val Herman, Truman Rose, Loin Faulkner, Steve Pretti, Jerome Burke, Byron Burke, Ed Boylon, E. Mott, Irene Meritt, M. Abrams, Chat Schaffinborg, and Leroy DeMott. The teachers were Anabel Hayes Reilly and Miss Bechen. (Courtesy of John Bishop.)

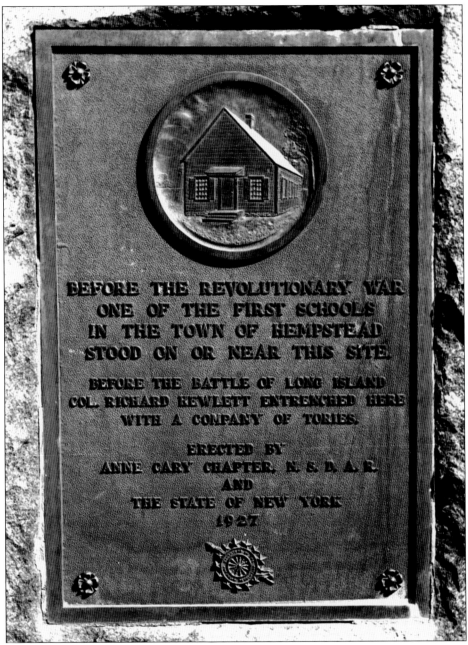

BEFORE THE REVOLUTIONARY WAR
ONE OF THE FIRST SCHOOLS
IN THE TOWN OF HEMPSTEAD
STOOD ON OR NEAR THIS SITE.

BEFORE THE BATTLE OF LONG ISLAND
COL. RICHARD HEWLETT ENTRENCHED HERE
WITH A COMPANY OF TORIES.

ERECTED BY
ANNE CARY CHAPTER, N. S. D. A. R.
AND
THE STATE OF NEW YORK
1927

East Rockaway had one of the first schools on Long Island. The school was erected during the American Revolution. This plaque caused concern because the Daughters of the American Revolution originally wanted to include the reference to Tory Richard Hewlett, and the commissioner of parks did not want that. Additionally, they planned to include a reference to "Bethany Sunday School first met in the school house used in 1867." The school stood where the village hall is today. Attendance was not compulsory, and for the most part, only the children of the wealthier people went to school. Schooling received little consideration in the early 19th century, and many people grew up illiterate. (Courtesy of the Historical Society of East Rockaway and Lynbrook.)

East Rockaway had outgrown the Woods Avenue School. Registration had increased to 320 with more expected. To meet district needs, a three-pronged plan was proposed and put into effect. It was decided to purchase land and build an eight-room school on the north and east side of the Long Island Rail Road tracks. Centre Avenue opened in the fall of 1924. (Courtesy of Timothy Silk.)

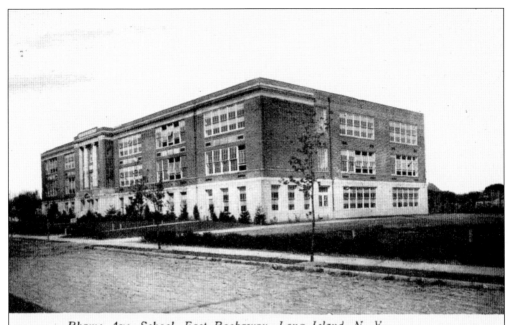

Rhame Ave. School, East Rockaway, Long Island, N. Y.

The Rhame Avenue School was built at the cost of $184,000. It had come in under budget. Classes opened on September 7, 1926. It marked the completion of a program to provide adequate school facilities for District No. 19. The board of education had decided to secure property in the village south of Main Street. (Courtesy of the Historical Society of East Rockaway and Lynbrook.)

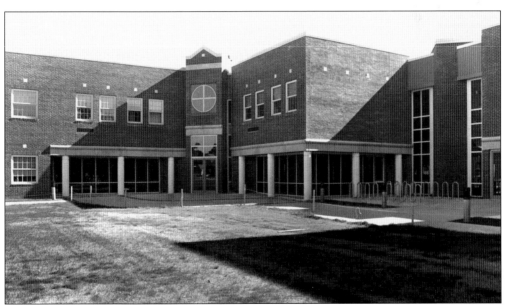

The Rhame Avenue School was seriously damaged by fire on January 20, 1986. It was discovered by a young man delivering morning papers. The fire had begun in a second-story lounge and quickly spread to the roof and several classrooms. Shortly thereafter, students were housed in neighboring school districts, which at the time had classrooms available for East Rockaway students to use during the reconstruction period. (Courtesy of Dr. Roseanne Melucci.)

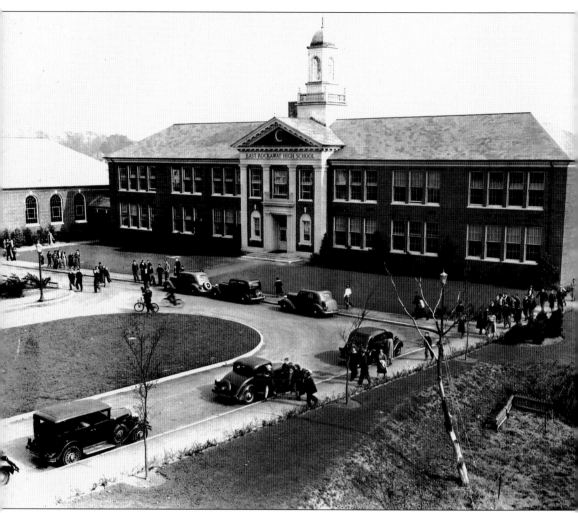

On October 20, 1933, voters authorized the building of a high school on Ocean Avenue. It was a U.S. government Works Progress Administration (WPA) grant. East Rockaway High School was completed in 1934. The school bell, cast in 1871 to call the schoolchildren, was gilded by the 1937 first graduating class and put in the tower above the main building. The class of 1962 was the first class to steal the bell from its tower. (Courtesy of Dr. Roseanne Melucci.)

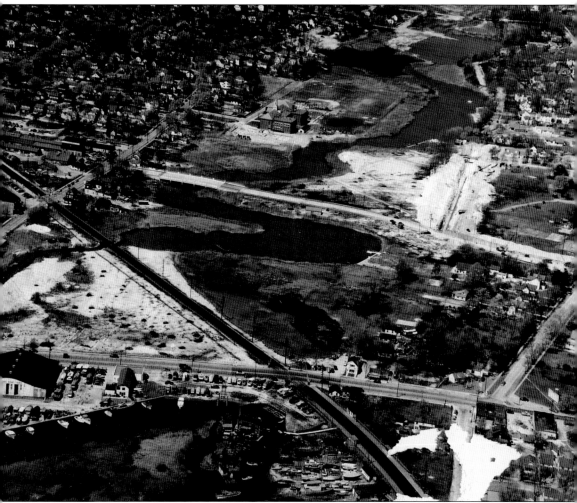

This aerial view is post 1934 because East Rockaway High School is located at the top of the map. The rather large white road to the south of the high school is Pearl Street, and the Davison Lumber Yard on Ocean Avenue is just west of it. The Davison Boat Yard is in the foreground on Atlantic Avenue, but Pathmark has not been built. (Courtesy of Dan Schmidt.)

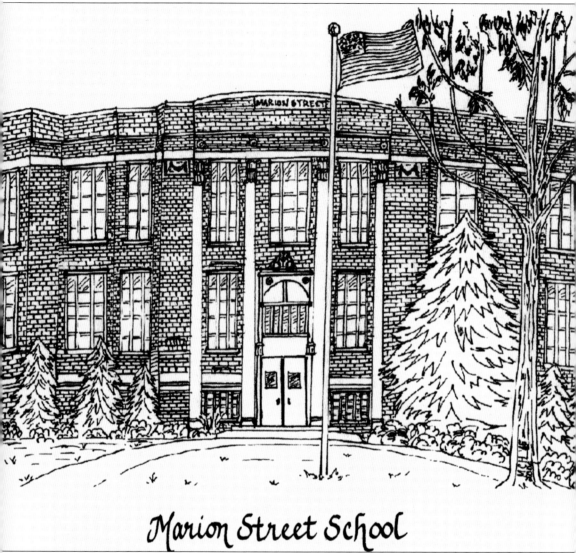

Marion Street School

The Marion Street School was built in 1927. Marion Street was the third elementary school built for the Lynbrook School Union Free District No. 20. It was built, however, on the corner of Marion Street and Waverly Avenue in the village of East Rockaway. This is yet another anomaly of the interwoven map of both East Rockaway and Lynbrook. (Courtesy of Mary Anne Hoesel.)

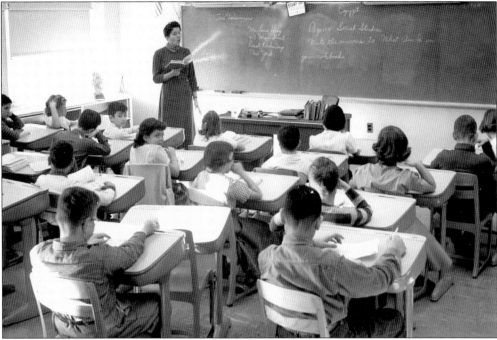

Lynbrook's fourth elementary school was built in 1954. The date on the board is 1954. Waverly Park School, as with Marion Street School, is located in the village of East Rockaway but part of District No. 20. This classroom scene is of one of the first classes held in Waverly Park School. (Courtesy of Waverly Park School.)

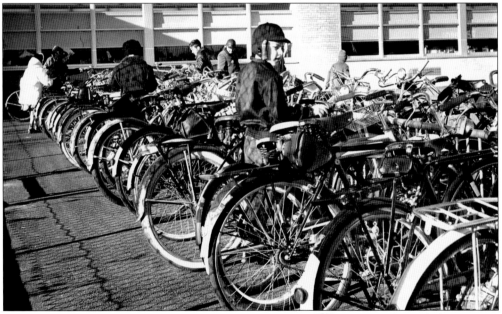

Waverly Park School is a neighborhood school. Note the number of bicycles and the fact that youngsters did not need helmets. The above scene is from yesteryear. While still a neighborhood school, most children either walk to school accompanied by an adult or are driven. (Courtesy of Waverly Park School.)

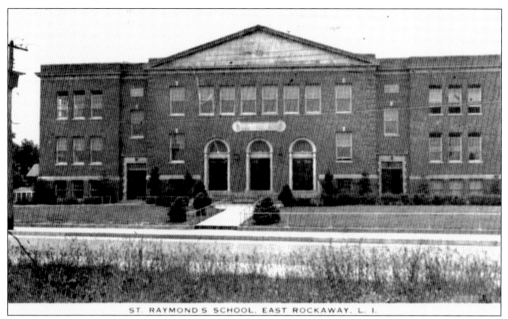

ST. RAYMOND'S SCHOOL, EAST ROCKAWAY, L. I.

St. Raymond's Roman Catholic School was built in 1926. It housed grades one to eight. The original school consisted of 12 classrooms, a gymnasium, and an auditorium, with the intent of accommodating 800 students with an average of 66 students per class. The beginning enrollment was 126 pupils. In 1961, a new wing was added to the school to meet increased enrollment. The picture below portrays St. Raymond's graduating eighth-grade class of 1942. (Above, courtesy of Rev. Richard Nilsson; below, courtesy of St. Raymond's Centennial Committee.)

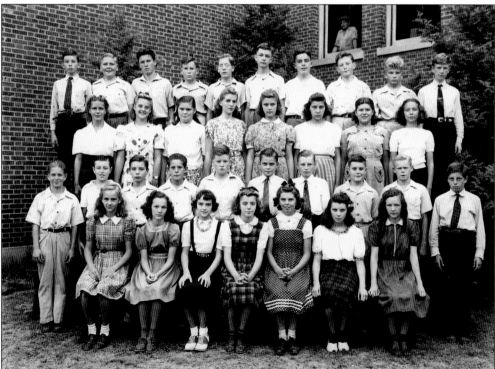

Six

THE RELIGIOUS INSTITUTIONS

As families moved into East Rockaway, they brought with them their cultural and religious traditions. After the Civil War, East Rockaway had barely 10 homes, a cluster of mills, dirt roads, and taverns, but there was no place of worship. Lorenzo D. Simons and his wife, Clara, changed that. They started a Sunday school for local children. Lorenzo and his son ran the Sunday school at Bethany Congregational Church for many years. St. Raymond's, which was founded in 1909, opened to serve the Catholics who were moving into East Rockaway. The Church of the Nazarene was founded in 1914. The last religious institution was formed in 1949 after World War II. The Hewlett East Rockaway Jewish Center was established so that the new residents would be able to give their children a Jewish education. The Tameling Estate, a former home of Rudy Vallee, was purchased. As with many of the older homes in East Rockaway, this was different. It had a roof garden wherein the grass had to be mowed on a regular basis. The religious institutions are an integral part of the community.

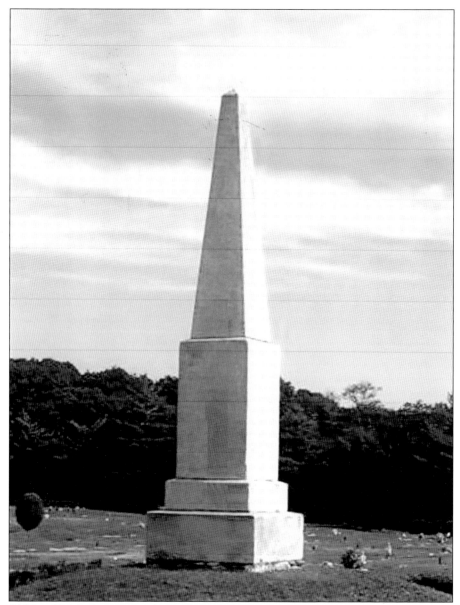

The Old Sand Hole Cemetery is located on Merrick Road at Ocean Avenue between Lynbrook and Rockville Centre on land donated by Isaac Denton, the original landowner. The two worst shipwrecks in Long Island history, the *Bristol* and the *Mexico*, occurred during the winter of 1836–1837. A lifeboat was kept in Near Rockaway at Oliver Denton's dooryard on Main Street ready for use. Denton had been appointed by the board of underwriters to look after their interests when a ship wrecked, and he was rewarded at times with a barrel of ale. The victims of these wrecks were interred in a common grave at this cemetery. According to the records of Peter T. Hewlett, "The frost was five foot deep in the ground; axes had to be used to dig a narrow trench where they were finally laid to rest." In 1840, this monument was purchased and crafted in Sing Sing prison in Ossining and brought to East Rockaway by sloop. Peter T. Hewlett, a coffin maker of East Rockaway, and the citizens of Queens County (Nassau County today) helped pay for the internment. (Courtesy of Robert L. Sympson.)

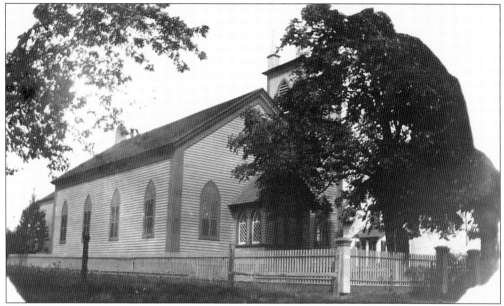

Bethany Church was a wood frame building with kerosene lamps and a wood-burning stove built about 1873. Itinerant ministers came to preach, marry, and baptize on Sunday nights prior to its being convened as the Bethany Congregational Church on May 26, 1885. In 1894, the Ladies Society was formed and the Union Sunday School and Bethany merged. In 1923, the Union Chapel was picked up, turned sideways, and moved back to make room for a larger church. (Courtesy of the Historical Society of East Rockaway and Lynbrook.)

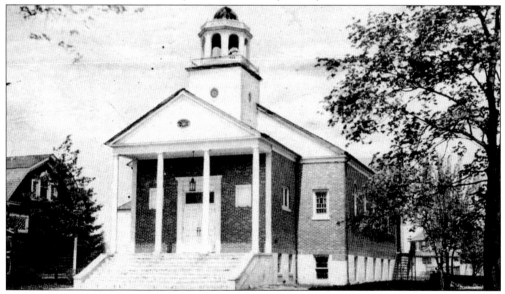

Bethany Church has always been a center of life in East Rockaway. A parsonage was built on Rhame Avenue in 1890. The Ladies Society was instrumental in the wave of changes that brought Bethany Church into the modern era. A new church was dedicated on October 28, 1928. During the Great Depression, it was difficult to keep the church open, and it had to be mortgaged. In 1947, these mortgages were burned and Bethany Church moved forward. (Courtesy of Rev. Richard Nilsson.)

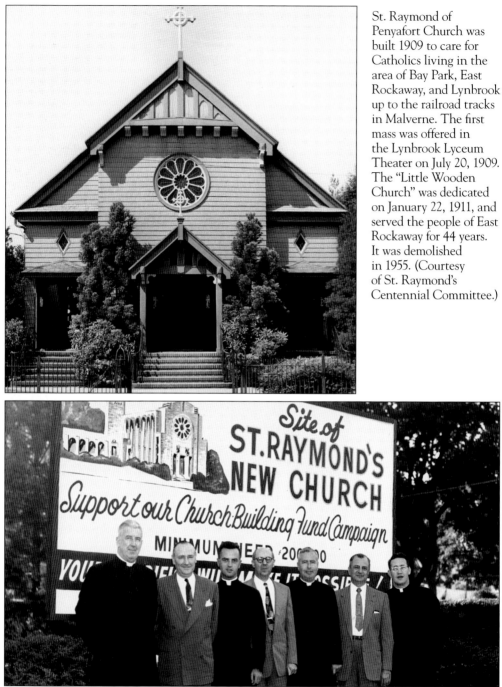

St. Raymond of Penyafort Church was built 1909 to care for Catholics living in the area of Bay Park, East Rockaway, and Lynbrook up to the railroad tracks in Malverne. The first mass was offered in the Lynbrook Lyceum Theater on July 20, 1909. The "Little Wooden Church" was dedicated on January 22, 1911, and served the people of East Rockaway for 44 years. It was demolished in 1955. (Courtesy of St. Raymond's Centennial Committee.)

Rev. William J. Walsh was appointed pastor in September 1946. He embarked on establishing a building fund to expand the parish facilities. A new church was built. Its campanile stretches up 100 feet and is an important part of the village skyline. Pictured from left to right are Msgr. William J. Walsh, Frank Sherin, Rev. Francis R. McMullen, Leo Wulliman, Rev. Thomas A. Judge, Alexander Provenzano, and Rev. John J. Mullen, leaders of the building committee. (Courtesy of Ann Weiler.)

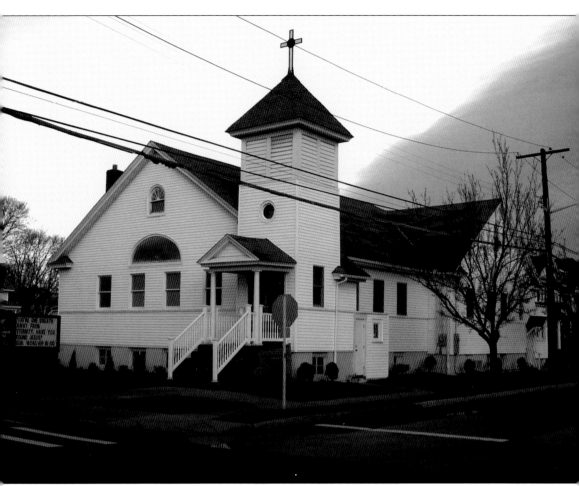

On May 7, 1913, the Beulah Mission Society of Oceanside formed Pentecostal Church of the Nazarene in East Rockaway. In the beginning, 19 members were admitted as charter members. A committee was assigned to choose a site for the church building. It chose the present site at the corner of Garfield Place and Ocean Avenue in East Rockaway. It purchased the land and ultimately built a church. (Courtesy of Robert L. Sympson.)

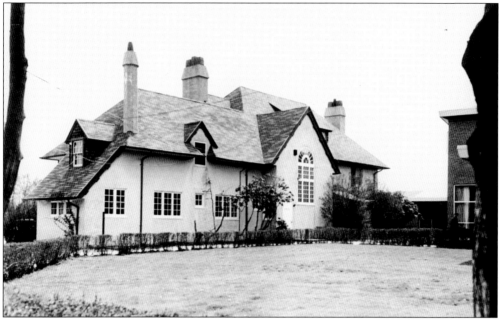

In the spring of 1949, a handful of men met in the basement of a home on Talfor Road to discuss concerns about where their children would learn the heritage of their faith, study its language and observances, and where they themselves could worship on the Sabbath and the high holy days. They organized a Jewish community without a formal name or home. On November 21, 1949, a binder was offered for the purchase of the Tameling Estate once owned by Rudy Vallee. The purchase consisted of two buildings on four acres. Since then Congregation Etz Chaim has been a force for community activities and educational functions. Over the years, it has hosted many notables such as Gerald Ford, Abba Eban, Abraham Ribicoff, and Yitzchak Rabin, to name but a few. Today the congregation has over 600 families. (Courtesy of the Hewlett East Rockaway Jewish Center.)

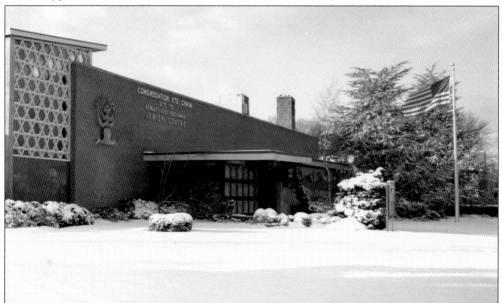

Seven

THE FAMILIES

Names that resonate all over Long Island also ring in East Rockaway. The Davison families of Charles, Oliver, and Robert still maintain a connection to East Rockaway. The Hewletts, the Dentons, the Rhames, and others have made East Rockaway what it is. Many of the streets, such as Davison Avenue, Rhame Avenue, Alexine Avenue, and Clark Street, bear the names of these families. East Rockaway has preserved an aura of being special, but as time brings change, time has changed East Rockaway. It is a small village whose families are important to its welfare. East Rockaway celebrated its centennial, and the village families came together to celebrate its heritage. East Rockaway is a village, school district, post office, and several neighborhoods, and they are not one and the same. Yet the village has joined the 21st century and come together as a community and embraces change and growth that its forefathers had resisted.

Peter and Oliver Hewlett, after several generations of trading, shipping, and land speculation, like other pioneer families, began to accumulate wealth and to build large manorial estates. Some magnificent homes were built toward the middle of the 18th century. Oliver Townsend Hewlett had made money as a mill owner, tradesman, exporter, and lumber supplier, and his home became a showcase of beauty. Peter Titus Hewlett, a self-made man, established his homestead

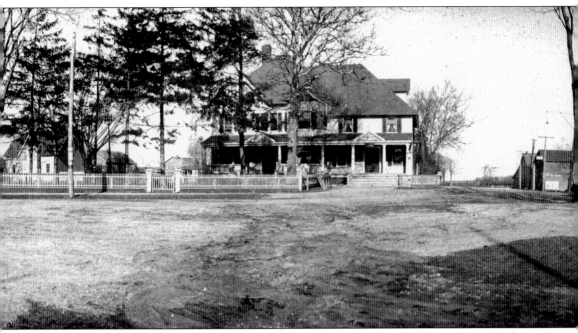

at 86 Main Street to the west of Oliver's, and both stood majestically at Near Rockaway Harbor. Peter's home was so significant that years later, when it was owned by Oliver Titus Hewlett, it was surveyed by the Historic American Buildings Survey/Historic American Engineering Record as a WPA project. (Courtesy of Gene Torborg.)

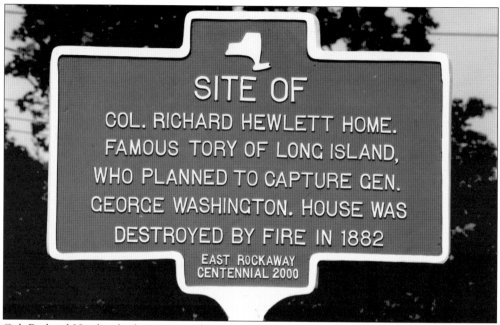

SITE OF
COL. RICHARD HEWLETT HOME.
FAMOUS TORY OF LONG ISLAND,
WHO PLANNED TO CAPTURE GEN.
GEORGE WASHINGTON. HOUSE WAS
DESTROYED BY FIRE IN 1882

EAST ROCKAWAY
CENTENNIAL 2000

Col. Richard Hewlett had once owned property on this site. The Wishing Well Nursing Home was located on Main Street between Carman and Grant Avenues. Previously known as the Carman House, it was owned by Richard Carman and leased to the Misses Curtis as a summer boardinghouse. It burned in 1884. Having been built in 1732, the Carman House had been for six generations the home of the Hewlett family. Colonel Hewlett had hidden behind a chimney when the colonials searched for him there during the American Revolution. John Hewlett recalled that "in the 1940s Burt Howland, a civil engineer, was working on an addition for the Nursing Home and came upon another foundation surrounding the present one. He felt it was the foundation for the Col. Richard Hewlett home logically located on Main Street." (Above, photograph by Donald Krendel; below, courtesy of James Pearson.)

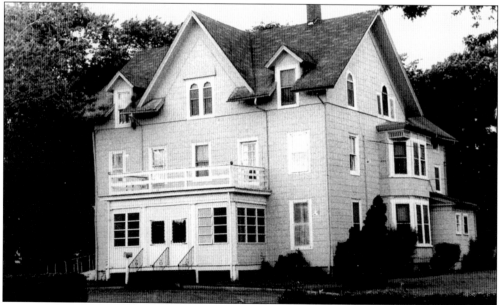

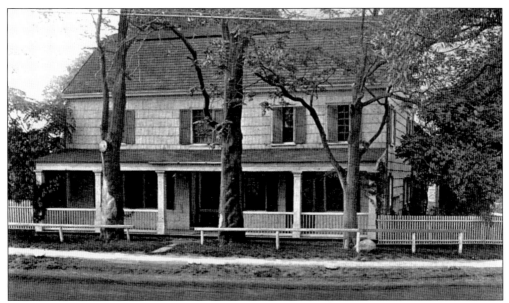

Peter Hewlett served in the New York State Militia. He was a cabinetmaker, carpenter, cooper, wagon builder, wheelwright, shipwright, coffin maker, and all-round repair man. He left the homestead in 1875 and lived here until his death in 1885. He had provided the coffins for the internment of the victims of the *Bristol* and *Mexico* shipwrecks. His home became the ultimate site of the East Rockaway Post Office. (Courtesy of the Historical Society of East Rockaway and Lynbrook.)

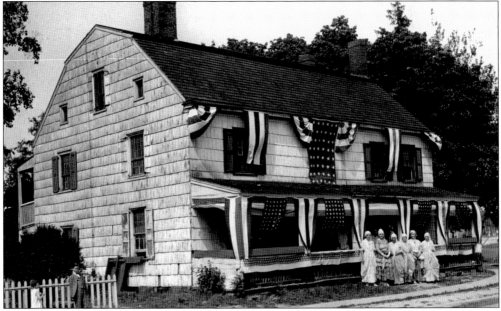

The Peter Hewlett house began to fall into disrepair after his death. Earlier it could not be distinguished from a modern Colonial mansion save for its low ceilings, small window panes, and mahogany stair rails. This was surveyed for a Historic American Buildings Survey/Historic American Engineering Record as a WPA project in 1935. (Courtesy of the Historical Society of East Rockaway and Lynbrook.)

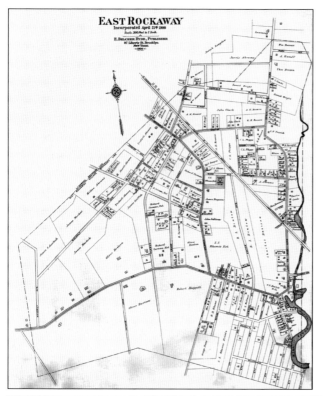

The 1906 E. Belcher Hyde map of East Rockaway illustrates the growth of families and their acquisition of land in East Rockaway. Many families retained their land, extended their authority, and lived and died in East Rockaway. East Rockaway today gives testimony to their influence. Many streets in East Rockaway bear these old family names. (Courtesy of the Historical Society of East Rockaway and Lynbrook.)

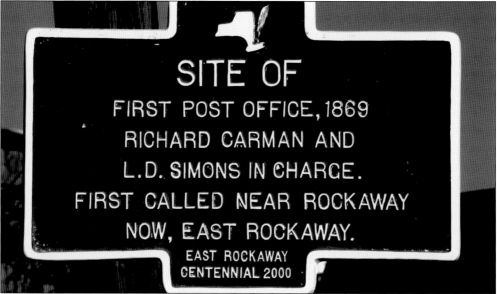

Col. Richard Hewlett was the only Near Rockaway resident who fought for the British during the American Revolution. His property was confiscated, and Colonel Hewlett took his family to Canada with funds provided by the English government. After his death, his wife, Mary, returned to East Rockaway. One son, Oliver, had remained in East Rockaway during the American Revolution. He later bought the property at Ocean and Atlantic Avenues. (Photograph by Donald Krendel.)

The Hewlett door pictured had been in the family since George Hewlett built the homestead about 1749. The grillwork is cast iron with frosted glass behind it. The doors, side by side, were cast in three parts and then riveted. In 1974, it was willed by the late Ceresies Hewlett to the Hewlett Woodmere School District, which in turn sold it to Nassau County in the 1990s. (Courtesy of John Hewlett.)

The mantel of this fireplace had been in the Hewlett family home for two centuries. Sara and John Hewlett are pictured. The mantel was donated by the family to the Nassau County Museum. When the mantel was moved in 1936, there was a note found that said that it had "been carved by my slave Nero in 1800." The owner of the slave is unknown. (Courtesy of John Hewlett.)

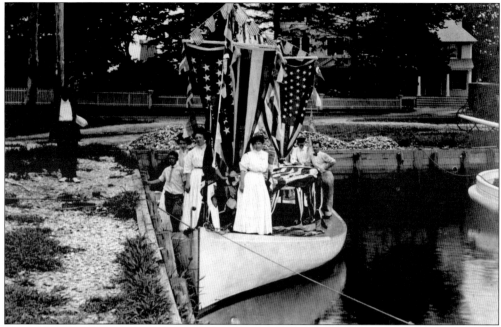

The Rhame family played an important role in the development of East Rockaway. Pictured on the Mill River across from the Peter Hewlett home are, from left to right, Samuel Rhame, his nephew Harry, and his wife, among other friends. The flag is a 45-star flag that became official on July 4, 1896, upon the admission of Utah as a state, on January 4, 1896. (Courtesy of Gene Torborg.)

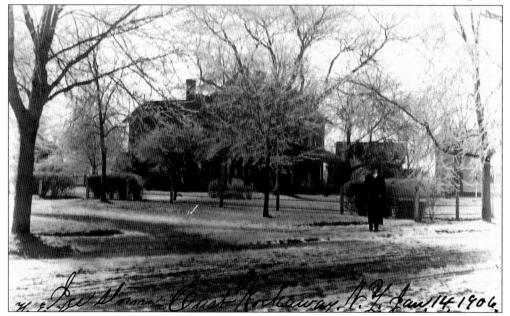

Rhame ran the mill for five years. He later married Charlotte Davison. He made his fortune as did many of the wealthier families in East Rockaway in real estate, oysters, and trade. He helped organize Bethany Congregational Church. His politics were Republican, and he was unswerving in his advocacy of the principles of the party. He could be considered one of the pillars of the village. (Courtesy of Gene Torborg.)

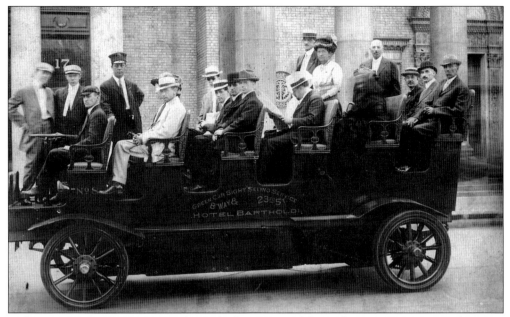

Sightseeing at the shore was popular at the beginning of the 20th century, as was travel to New York City. Recorded here in 1910, among others, are four people well known in East Rockaway: Israel Langdon; Edward T. Neu, barber; store owner Samuel Rhame; and Richardson B. Combes on a sightseeing trip to the Hotel Bartholdi. (Courtesy of Gene Torborg.)

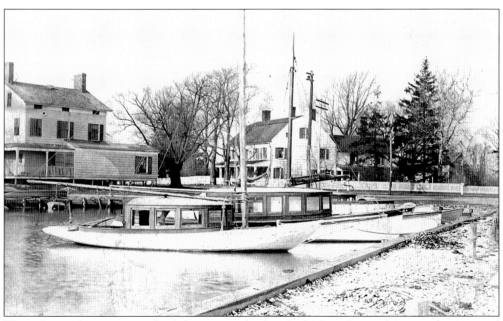

Rhame's wooden store on the left was on the bend of Main Street. Many gatherings and movements originated there. Rhame's father invested in local real estate, made a fortune in coastal trading and oysters, and ran the general store that he had bought from Oliver Denton, whose grandfather built it. Peter Hewlett's home is in the background, and oyster boats on Dock Street are in the foreground. (Courtesy of Gene Torborg.)

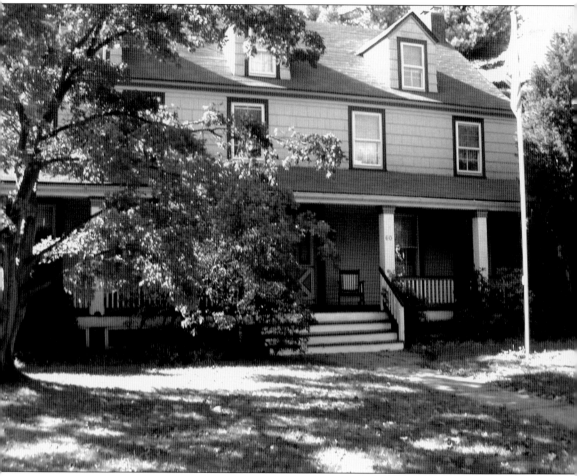

Oliver Denton purchased a tavern in 1808 and remodeled it into a building that became the family homestead. The house was so shady that the setting is remembered as one of a moss-covered brick walk up to the house with moss everywhere. He was receiver of taxes and was known as "Banker Denton" and as "Miser Denton" by the children. (Courtesy of the Historical Society of East Rockaway and Lynbrook.)

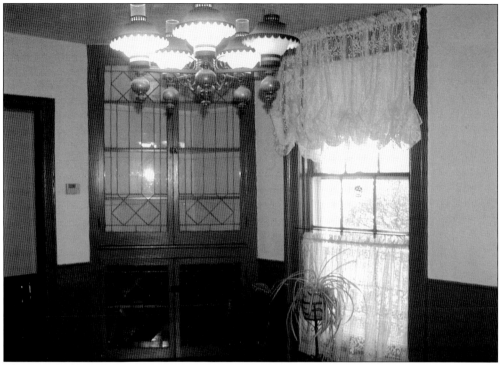

The grand old residence has maintained its beauty and integrity. The upper floor was a large ballroom. The window pictured is beautiful and typical of taverns in those days. The corner cabinet has been preserved. The grape arbor supported several varieties of grapes. At the sides of the arbor, horseradish flourished. The grapes and radishes did well, due to the water from the kitchen sink being led off beneath the arbor. (Courtesy of the Historical Society of East Rockaway and Lynbrook.)

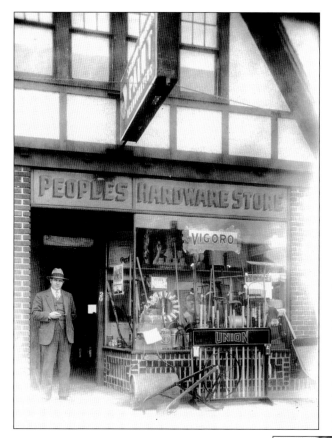

The Thomas Clark family is representative of many East Rockaway families. They came to the village in the early 1800s and remained. They became pillars of the community, giving of their time and talent. John Clark lived on Centre Avenue in an imposing mansion, which is still standing. He donated land for the Clark Street firehouse. His son Thomas E. owned the People's Hardware Store on 20 Davison Plaza with Evan Johnson. He served as an East Rockaway village trustee in the 1930s. His son Kenneth E. is pictured in 1942 as he set off to serve in World War II. The People's Hardware Store became East Rockaway Hardware, owned by Kenneth T. Clark, now located on Main Street and Atlantic Avenue. (Courtesy of Kenneth T. Clark.)

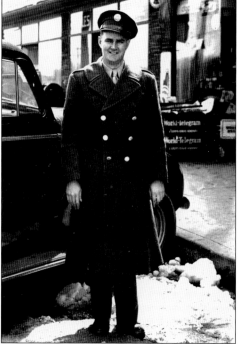

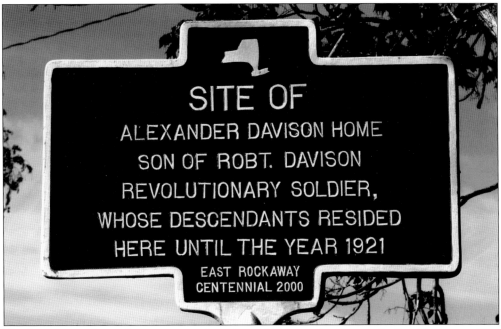

SITE OF
ALEXANDER DAVISON HOME
SON OF ROBT. DAVISON
REVOLUTIONARY SOLDIER,
WHOSE DESCENDANTS RESIDED
HERE UNTIL THE YEAR 1921
EAST ROCKAWAY
CENTENNIAL 2000

The historic marker indicates yet another place of historic significance in East Rockaway. The Davison homestead in this picture dates from 1870. It was located on Ocean Avenue opposite the mill before a second story and rear extension were added. Pictured from left to right are Mary Alma Wright Davison, daughters Josephine and Katherine, unidentified, son Robert, unidentified, and daughter Alexine. (Above, photograph by Donald Krendel; below, courtesy of the Old Grist Mill Historical Museum.)

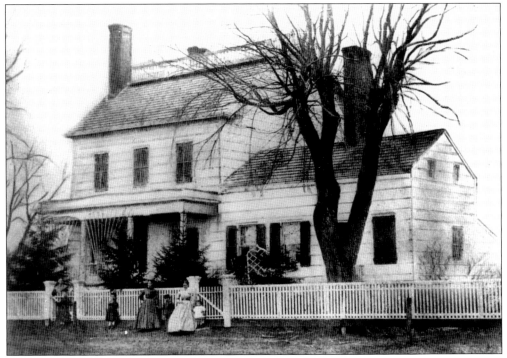

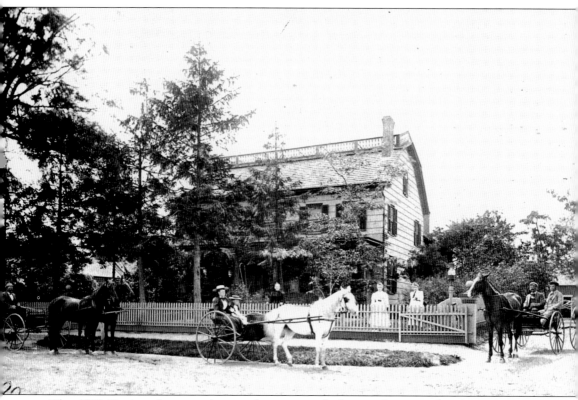

The 1890 Davison homestead is at the corner of what is Ocean and Atlantic Avenues. Improvements have been made. Pictured to the left driving the cart is Charles Davison. The woman pictured behind the fence and behind the horse is Mary Alma Wright Davison, his wife, and one of the young men in the cart to the right is Herbert Davison. (Courtesy of the Historical Society of East Rockaway and Lynbrook.)

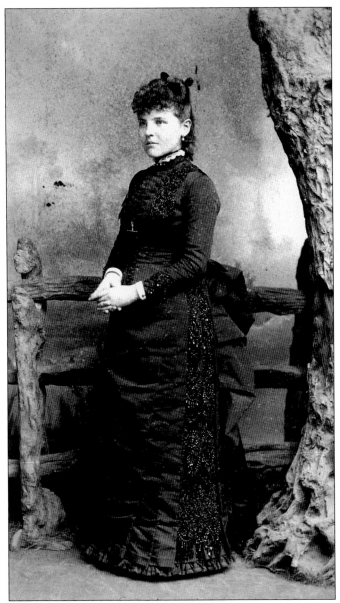

Alexine Davison married Robert Nix in 1889, and they lived in the northernmost house on Davison Row for a number of years. The Nix family moved to their Casa Blanca Plantation in South Carolina and came north to East Rockaway in the summer. Their mode of travel between homes was either by railroad or by the less expensive and more convenient boat trip on the Clyde Steamship Line to Charleston. Alexine endured unending seasickness during each three-day steamship trip. Family members recall Aunt Alexine as erect in posture with a regal demeanor, as her affluence suggested. Younger family members were expected to dress up and display their very best manners when in the presence of "Aunt Al." Style was part of her allure for the younger generation. Her sizable collection of pierced earrings was the envy of her great-niece Nancy Davison Harding. Great-nephew Robert Henry Davison recalls her liberal and dazzling use of mascara, even in her later years. (Courtesy of Oliver Simonson Davison.)

The John and Ada Davison Home predates the homestead. In *Early Memories: For All the Grandchildren*, 1984, Alma Nix stated, "It was a low house and very deep which contributed to its aura of venerable age. Behind the house was a big back yard where the family laundry dried in the sun and swung in the breeze. But this grassy spot was destined for bigger things. It was to be the scene of a strawberry festival. Many preparations had to be made. Card tables were set up and covered with white cloths. A few chairs for the elderly were unfolded. Nearby the Chinese lanterns, which were hanging among the trees, swayed, fluttered, and gave a lovely light. Of course, there were strawberries, big luscious ones served in various ways, but no strawberry ice cream. It was a time before electric freezers were invented and making ice cream was a small personal affair powered by the energy of at strong right arm. It was the hey-day of the strawberry shortcake, made with the thickest of cream. I don't remember eating anything. We children just ran about wildly as children are wont to do." (Courtesy of Gene Torborg.)

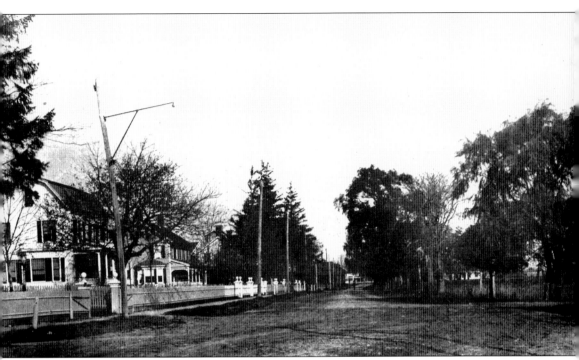

Early landownership often rested within families. Davison Row, facing east on Ocean Avenue, had the homestead owned by Charles Davison and the homes owned by Herbert Davison, Robert Davison, and John Davison, the Nix home adjacent to open fields, and finally the Long Island Rail Road, which bordered the Nix home on the north. Today there are no vestiges of these beautiful homes in this area. (Courtesy of the Historical Society of East Rockaway and Lynbrook.)

Robert Henry Davison, after the death of his father, Charles, worked at the mill with his brothers Herbert and John. Deliveries were still made by horse and wagon and continued for some time. It was, according to Charles Wright Davison, his son, because his father loved horses and did not want to give them up. Finally, automotive trucks were purchased for the delivery of lumber and mason supplies. This was the end of an era. (Courtesy of Robert H. Davison.)

Charles Wright Davison was born in 1892. His desire for his family was stated simply: "I can wish for nothing better for the ones I love – and that follow me – than to have the advantage to live with nature and to love the things God created for us all. This was all mine and I hope by it, I am a better father and a better American." (Courtesy of Robert H. Davison.)

Davison Row is in contrast to its usual picture from Ocean Avenue. Here the homes overlook the Mill River, also known as East Rockaway Creek or Parsonage Creek. Suffice to say it is a beautiful water scene of East Rockaway of yesteryear. (Courtesy of Gene Torborg.)

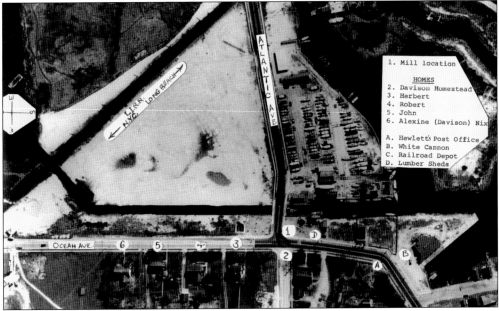

This map delineates the Davison properties on Atlantic Avenue and Ocean Avenue. This is an early aerial map of East Rockaway. It is interesting because it notes the properties of the Charles Davison family and other Davison homes, including the homestead, the Herbert, Robert, and John Davison homes, and the Nix home. It does not indicate the property of the Oliver Davison family, which is the boatyard pictured to the north of the mill and the lumber sheds. Oliver and his son Russell owned the land and boatyard. An aside that one might be able to discern is that Russell bought 10 feet along the entire coast of Chowder Island, which is hidden by the sign. This was done to protect his present and the future interest of boatyard owners. (Courtesy of Robert H. Davison.)

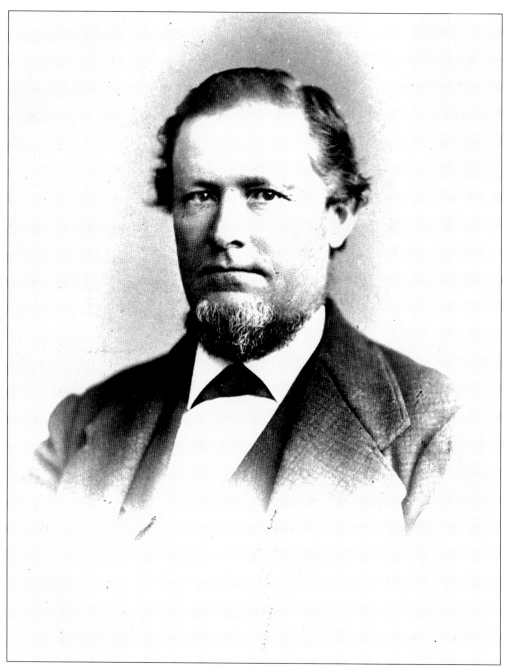

Oliver S. Davison, born in 1868, was the son of Oliver Davison. He invested in real estate and building. He built a number of area houses. He owned a lumber mill in Cedarhurst. His son Russell Simonson Davison ran the Davison Boat Yard for many years. (Courtesy of Oliver Simonson Davison.)

Russell, son of Oliver S., was a hardworking talented craftsman. He could add, subtract, multiply, and divide engines. There was not one piece of motorized equipment that daunted him. Russell was a taskmaster and diligently worked with his sons and his staff to make them the best in the boating business and ran the Davison Boat Yard with the same vigor. (Courtesy of Oliver Simonson Davison.)

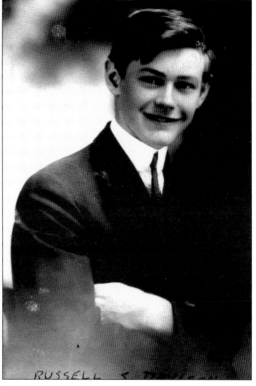

RUSSELL S. D[...]

Russell was a boatbuilder and repairman. He built houses in East Rockaway at 25 and 35 Davison Avenue. He built one at 11 Flint Road. At the head of Davison Avenue, he erected a home at 17 Sachem Road that still has the barn in the rear where the family lived while he constructed this house. These homes are still standing. He also built a home at 48 Franklin Street and houses in Angle Sea. (Courtesy of Oliver Simonson Davison.)

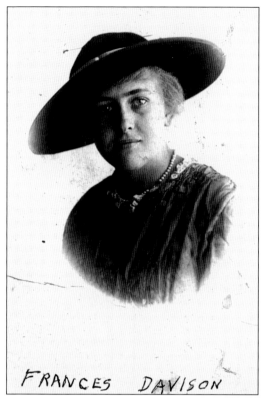

FRANCES DAVISON

Frances Smith Davison played a pivotal role in the lives of Russell and their children, Oliver, Russell Jr., Betty, and Doris. She sailed when Russell had family houses to fix in distant places. She drove the family to accompany him when he pursued his love of boat racing. Frances was a member of the Daughters of the American Revolution (Courtesy of Oliver Simonson Davison.)

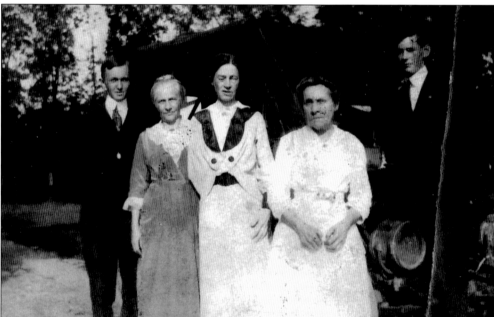

Seen here are, from left to right, Lyman Davison, great aunts Amelia, Irene, and Susan Davison, and Russell Davison. The ladies, known as the "Old Maids," especially Irene Davison, were very generous to their nephews and to the village of East Rockaway. Irene, as well as Amelia, was an inveterate suffragette. (Courtesy of Oliver Simonson Davison.)

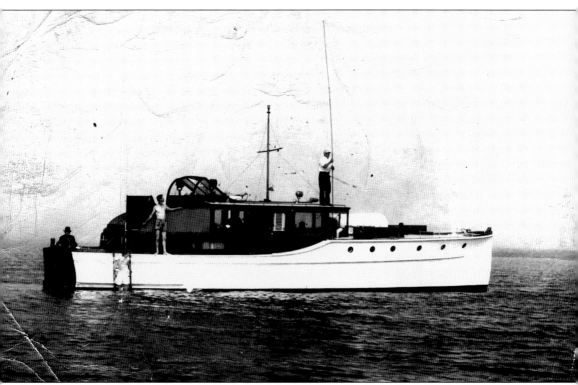

The *Franrus* is one of several boats owned by Russell Sr. All his boats were named *Franrus* after his wife, Frances, and himself. He is at the helm. His son Oliver appears to be seeking permission to enjoy a swim. Son Russell Jr. is ready too. A friend is at the rear of the boat. (Courtesy of Dan Schmidt.)

The Oliver Davison mansion was located at 245 Main Street. Early maps indicate the vast expanse of land held by the Davison family. Oliver S. Davison, a master craftsman, built this mansion. The staircase rail is bi-level. The lower one is for the little people to be able to ascend the stairs. The regular one is hand-hewn mahogany. The Davison mansion still stands in its original location. Main Street is now 150 feet north. Neighboring parcels were all sold. (Courtesy of Robert L. Sympson.)

Eight

HOTELS AND RESTAURANTS

East Rockaway boasted several restaurants and many boardinghouses before it became modern. There had been a number of large and beautiful homes. The railroad took city tourists through East Rockaway to the shore. Sometimes these visitors stayed because East Rockaway had a beach of its own. The circumstances lent themselves to entrepreneurs who made their homes into boardinghouses to accommodate the visitors from the city. The Great Depression aided in the changeover of home to boardinghouse to tavern. People were hard-pressed to keep their homes, and the lure of income made it possible for restaurants, bars, and speakeasies to emerge. This changed with the advent of World War II. Returning veterans needed a place to live and raise their families. A few of the homes have been preserved. Others on the large plots of land became the victims of the wrecking ball, and homes were built that resembled each other. It was not until there was a new wave of construction that the homes took on a singular look again.

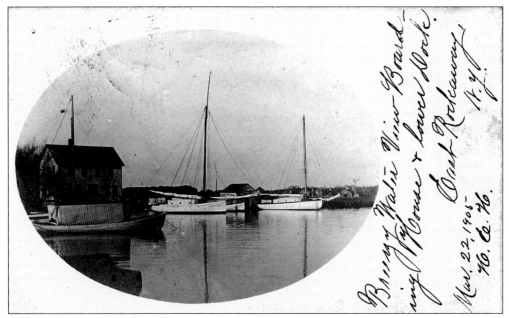

The Breezy Waterview, located at 58 Front Street, is yet another house used to accommodate visitors to East Rockaway in the first decade of the 20th century. It was owned by Mrs. Dyker White and could house 40 persons. She charged $7 per week. At the beginning of the 20th century, East Rockaway began to grow, and with incorporation came many amenities such as streetlights, equalization of taxes, and promotion of tourism to the nearby beaches and shores. It also saw an increase in complaints to village officials as to noise and rowdiness as these establishments changed to taverns. Note the handwriting is similar and most likely the writer is Hattie Hewlett. (Above, courtesy of the Historical Society of East Rockaway and Lynbrook; below, courtesy of Gene Torborg.)

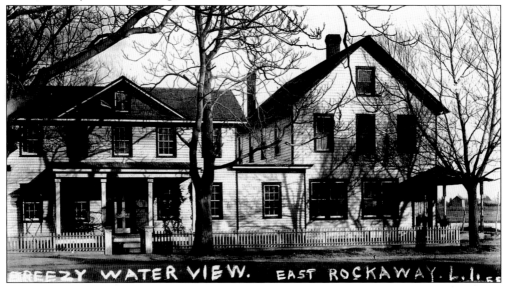

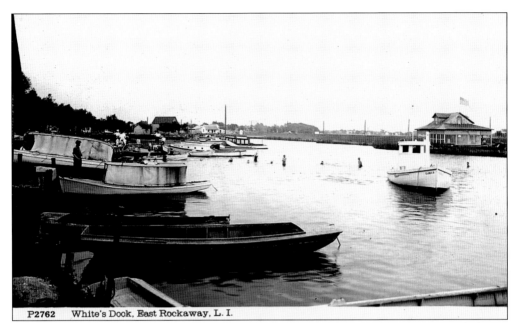

P2762 White's Dock, East Rockaway, L. I.

White's Dock and White's Boardinghouse are located at the foot of Front Street before it hooks south. Walter White helped found Carman and Dunne Surveyors in Lynbrook. He was a well-respected engineer and surveyor. He worked with Delamater S. Denton and conducted many local surveys and drew up maps for East Rockaway as well as surrounding villages. Mrs. White was famous for her clam pie that she served every night at the boardinghouse. White's Dock was also known as the site of many early submersion baptisms. (Courtesy of the Historical Society of East Rockaway and Lynbrook.)

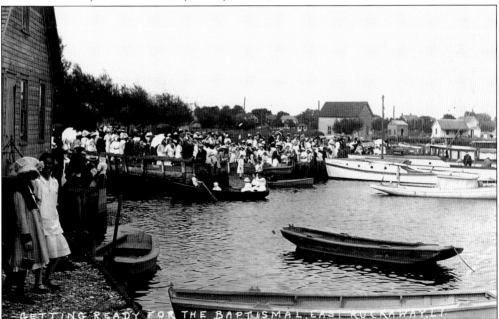

GETTING READY FOR THE BAPTISMAL, EAST ROCKAWAY, L.I.

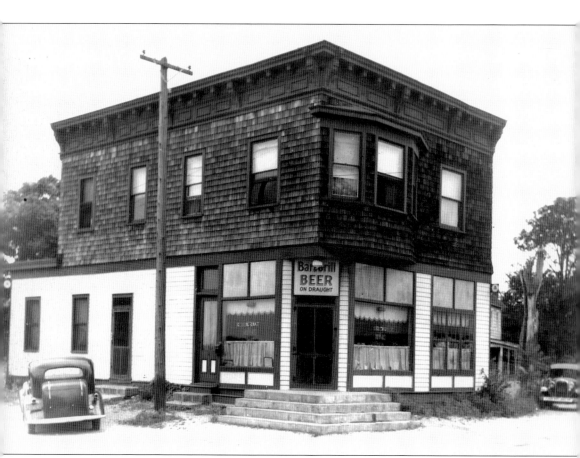

The Wild Duck Inn is the name most people remember for this 19th-century building. It has been Bar and Grill, Win and Jin, and Pier One, among others. Survival is its name. While many wish to preserve it, others see the value of land near the waterfront. How long it will stand remains to be seen. It is one of the few old buildings left in East Rockaway. (Courtesy of Gene Torborg.)

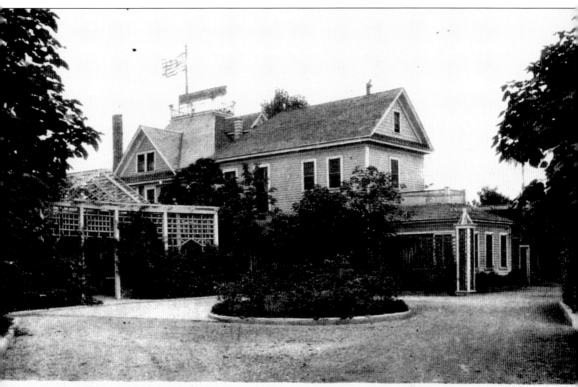

Original Henri Restaurant, Lynbrook, N. Y. (Tel. Lynbrook 759)

The "Original Henri Restaurant" opened in 1910. It was located on Scranton Avenue, East Rockaway between Waverly Avenue and Irving Place. The restaurant had a Lynbrook post office. Henri Charpentier's cuisine was superb. As his reputation grew, so did a following of famous clients. Business expanded until prohibition in 1922. The ambience at Henri's was forever changed. (Courtesy of the Historical Society of East Rockaway and Lynbrook.)

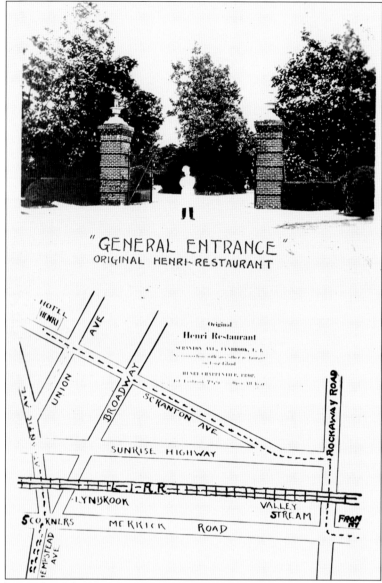

"GENERAL ENTRANCE"
ORIGINAL HENRI-RESTAURANT

With the advent of prohibition, Henri Charpentier changed the focus of his restaurant to attract common folk. He introduced rooftop dancing with a live band and popular-priced menus. Neighbors complained he had violated the zoning code of 1927. The village had adopted an ordinance that placed Scranton Avenue and the premises occupied by Henri's in the restricted area. The ordinance expressly allowed in Section 4 thereof that "any lawful use existing at the time of the passage of this ordinance may be continued though not conforming to the rules and regulations of the district for which it is maintained." The village attorney held Henri's use of premises adjoining a restaurant for outside dining and dancing during the summer in this locality as proper restaurant use. Thus local residents who had complained bitterly about the noise and excessive automobile parking lost their fight. The specter of unpaid Nassau County taxes closed Henri's Restaurant forever in 1938. Later there was an effort to rezone the property for apartments. It failed. Houses were built in the area after World War II. (Courtesy of the Historical Society of East Rockaway and Lynbrook.)

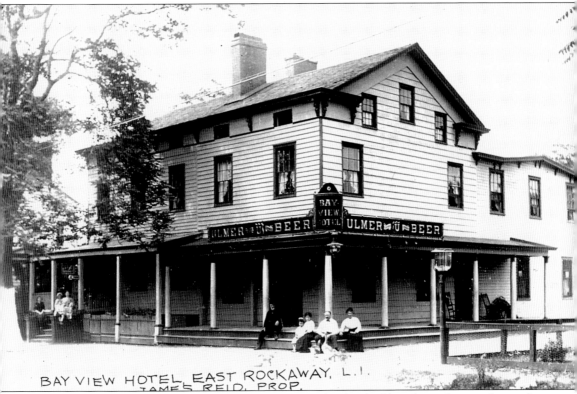

BAY VIEW HOTEL, EAST ROCKAWAY, L.I.
JAMES REID, PROP.

The Bay View Hotel succeeded C. W. Wright's Hotel. This building has a long and varied history. Earliest maps show it as the stagecoach stop at C. W. Wright's Hotel. Then the Bay View Hotel emerged. The Ulmer Brewing Company, Jim Reid's Hotel, and Greenwald's seamlessly appear, and finally Henry's Patio Restaurant is established with the final name of this building having been the Nassau Hotel. (Courtesy of Rev. Richard Nilsson.)

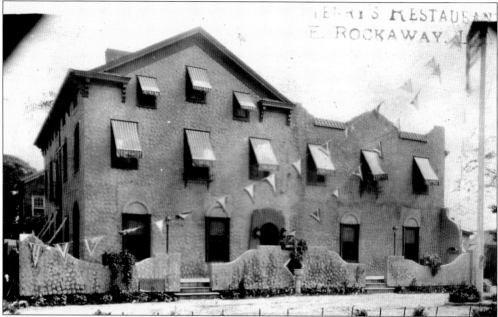

Henry's Patio Restaurant was a restaurant not patronized by locals. It was really a speakeasy in disguise. It catered to a rich urban crowd. While it was not as elegant as Henri Charpentier's restaurant on Scranton Avenue, John Bishop recalled that as a youngster, big limousines with only their parking lights lit came to Henry's on weekends. Edith Langdon bought the hotel from Henry and Emmy Baer (a woman known for her many dachshunds), renamed it Nassau Hotel, and finally sold it to the East Rockaway Fire Department, which razed it for a parking lot. Note that in the right-hand corner, one can see the fire alarm flower planter, formerly the fire bell and railroad ring used to summon firemen. (Above, courtesy of Rev. Richard Nilsson; below, courtesy of Gene Torborg.)

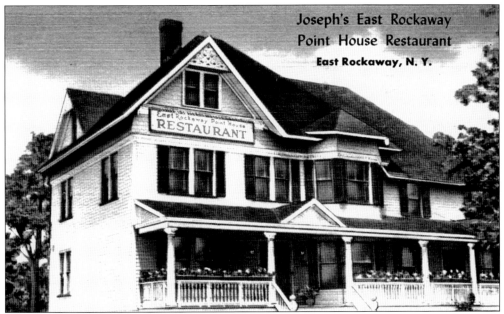

The East Point House acquiesced to modernity. It became a tavern and restaurant, as did many of the old homes in East Rockaway at the beginning of the 20th century. It later became a relatively modish restaurant with a Colonial panache. It was rumored but never verified that George Washington had enjoyed the ambience of the setting. (Courtesy of the Historical Society of East Rockaway and Lynbrook.)

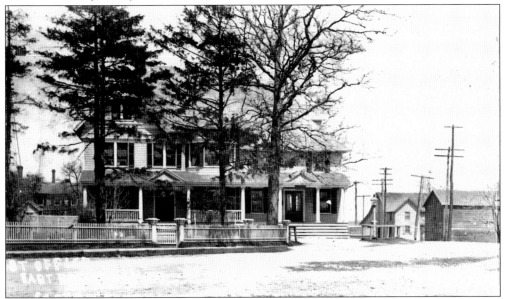

In 1894, the East Point Inn, formerly the Oliver Hewlett house, suffered one of the first conflagrations of any size. This event emphasized the importance of organizing a fire department. The home was rebuilt. It literally disappeared at dawn on April 5, 2004, with the advent of the wrecking ball. The destruction of the East Point Inn removed a vital historical asset, but it also began a resurgence of interest in the importance of historical preservation. (Courtesy of Rev. Richard Nilsson.)

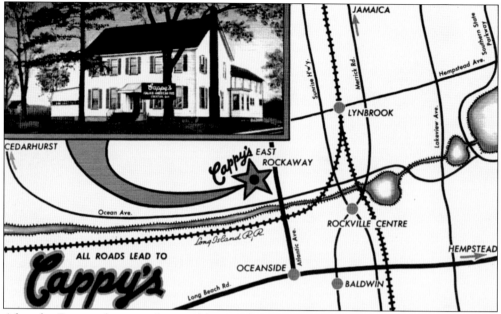

After the Davison homestead was sold, several restaurants were established on the premises. Cappy's Restaurant, later the Black and White Restaurant, was set up here, followed by Emil's in 1976. Note Main Street to the south had not been cut through to connect with Atlantic Avenue. Today the Davison homestead corner houses a Wendy's restaurant. (Courtesy of Rev. Richard Nilsson.)

The first public oven was in the area of the hub of East Rockaway. When the oak tree was pulled out of Mill River in 1903, men at the time pondered that the tree was probably a remnant of the first oven because old-timers could not remember trees in the surrounding fields. (Photograph by Donald Krendel.)

102

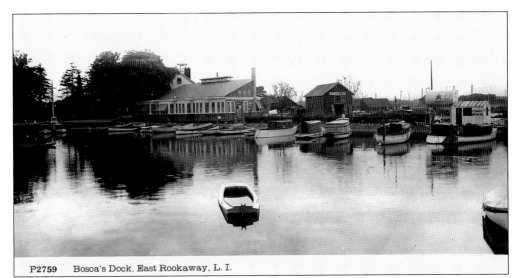

P2759 Bosoa's Dock, East Rookaway, L. I.

The White Cannon Hotel has a long history in East Rockaway. It opened around 1800 and was run by John F. Rhodes as a rooming house and general store in competition with Sam Rhame. At one time, it was the post office. John Bosca bought it in 1910. He was a war veteran, and the government awarded him a cannon. At the cannon dedication on July 4, 1910, a fire broke out, causing the crowd to disperse. It was subsequently called Len Smith's Hotel, Lehrmann's Hotel, and Richmars Hotel. In 1914, the Madison Square Roof Garden Directors purportedly bought it. It later housed the American Legion until 1936 and ultimately became the White Cannon Inn. (Above, courtesy of Gene Torborg; below, courtesy of the Historical Society of East Rockaway and Lynbrook.)

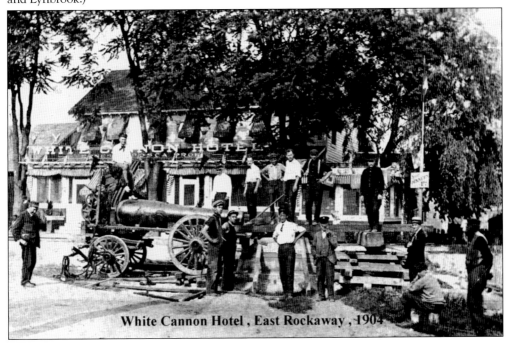

White Cannon Hotel , East Rockaway , 1904

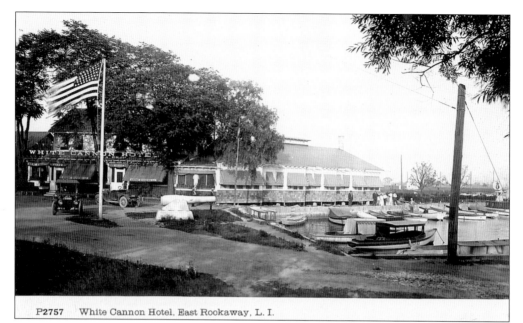

P2757 White Cannon Hotel, East Rockaway, L. I.

The ambiance of the White Cannon Inn is very elegant. People could dock their boats and enjoy excellent food in luxurious surroundings and return to the water with great contentment. Patrons could also drive right up to the door. For years a restaurant, it became a dine-and-dance hall with a far different atmosphere as time progressed. Prohibition had a deleterious effect on the White Cannon Inn, as it did on most businesses. A good number of these epicurean establishments disappeared, and East Rockaway forged ahead. Change and growth came to pass. (Courtesy of Rev. Richard Nilsson.)

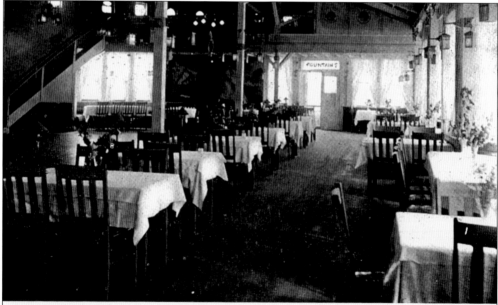

DINING ROOM OF WHITE CANNON INN, East Rockaway, L. I., on road from Long Beach to Far Rockaway.

The White Cannon Inn burned down in 1950. Its history had been long-lived and extensive. It passed into oblivion. The cannon remains and is preserved at the head of the Talfor basin. Inscribed on the cannon is "Fort Pitt 1861 Cannon #64 8541 LBS JHN." The picture below dates back to the 1914 F. W. Beers Map, which indicates that the cannon was facing what is now Althouse Avenue. The homes pictured were Davison-owned homes, part of the family presence in East Rockaway. (Right, courtesy of Gene Torborg; below, courtesy of the Historical Society of East Rockaway and Lynbrook.)

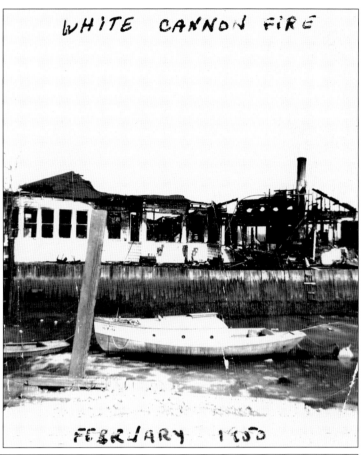

WHITE CANNON FIRE

FEBRUARY 1950

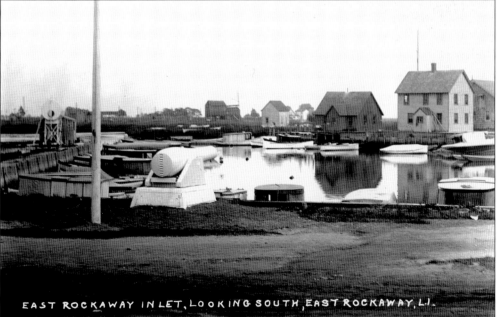

EAST ROCKAWAY INLET, LOOKING SOUTH, EAST ROCKAWAY, L.I.

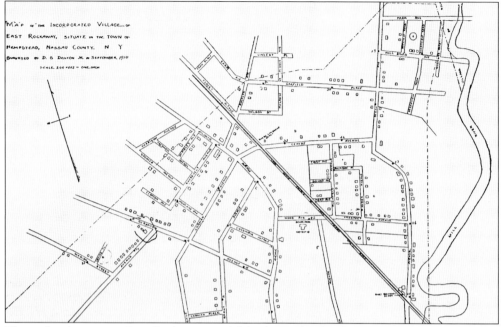

The railroad came to East Rockaway, and life changed. The first station was called South Lynbrook on the northwest side of Centre Avenue. The trains ran in the summer and were called "huckleberries" because they were so slow and made so many stops that passengers could get off and pick huckleberries along the route. The railroad provided access to the seashore for New York City dwellers at 58¢ per ride. At one time, there were three railroad stops in East Rockaway. Subsequently, the Centre Avenue station was built on the southeastern side of Centre Avenue. The railroad caretaker's family lived upstairs over the station. The present-day East Rockaway station was established in 1890. The civic association tax roll of the village of East Rockaway from 1912 indicates there was a third railroad station called Atlantic Depot west of Ocean Avenue. (Above, courtesy of the East Rockaway Library; below, courtesy of Rev. Richard Nilsson.)

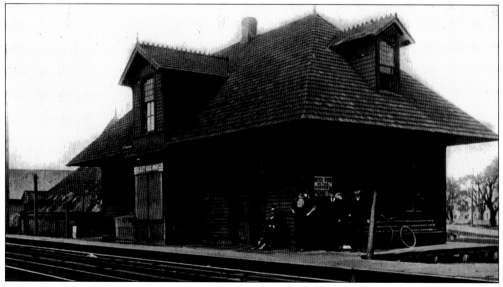

Nine

STREET SCENES

Homes built in the 19th century have a lure because many of them were large and appeared luxurious to those on the outside. There were many family homes in East Rockaway that remained in the families for generations. The Clark family house on Centre Avenue and the Oliver Davison mansion formerly on Main Street remain. The village had different homes for different families and for different sections. From pictures, it appears that the larger homes lined the streets from the waterfront to village hall. Smaller homes were built in the southern area of East Rockaway. East Rockaway is a one-square-mile village. There is no doubt that there will be a panoply of differences within that square mile. Today East Rockaway enjoys many large homes, smaller homes, historic homes, and apartment houses, to name some of the housing demarcations. Its rural and bucolic picture is no longer on the surface of one's vision, but it remains on the periphery as East Rockaway grows and makes a concerted effort to preserve its heritage and feature the beauty of its past.

John Bishop notes that the H. H. Schmidt residence was on the corner of Main Street and Baiseley Avenue. It became Nelson's Nursing Home. Here the Windsor Land Development Company had its temporary field offices. It, along with Realty Associates, was the builder of Bay Park and some of the houses on Adams and Dart Streets. During the winter, the rear of the property was stacked high with frozen lumber for these projects. (Left, courtesy of East Rockaway Library; below, courtesy of Gene Torborg.)

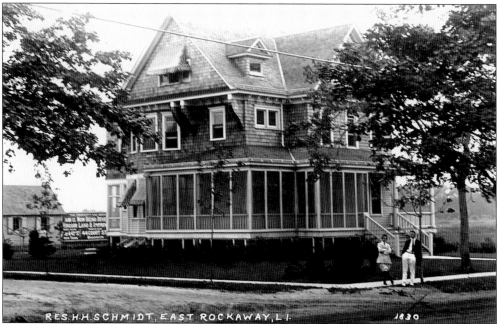

RES. H.H.SCHMIDT, EAST ROCKAWAY, L.I. 1830

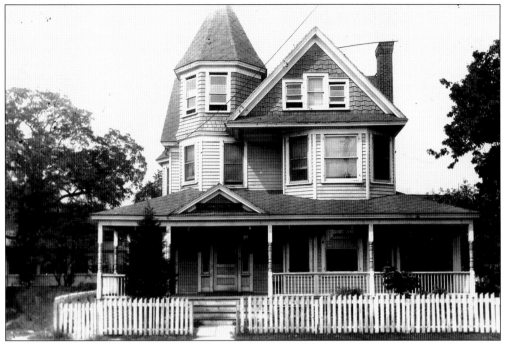

The East Rockaway Democratic Club was housed in this beautiful home on Centre Avenue. There is still part of it remaining, but the front has been replaced with small stores similar to those to the left. The store on the corner of Centre and Atlantic Avenues, to the left in the picture below, was Kuckens Grocery replaced by St. Raymond's rectory and front yard. Note that the banner across Centre Avenue supports Franklin D. Roosevelt and John N. Garner. (Courtesy of Gene Torborg.)

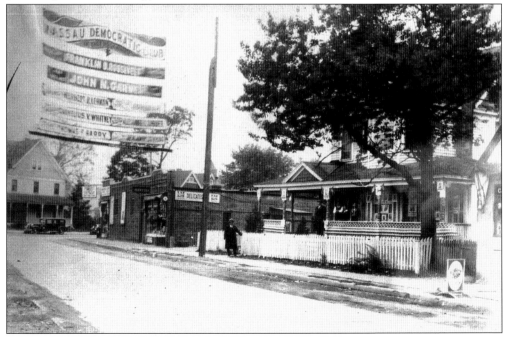

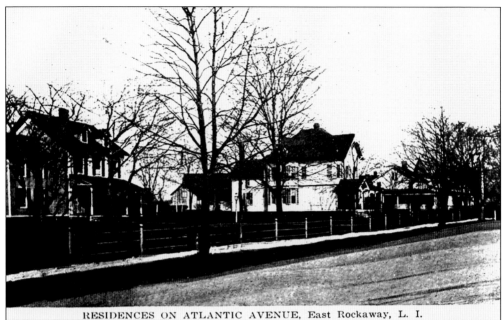

RESIDENCES ON ATLANTIC AVENUE, East Rockaway, L. I.

East Rockaway evidences vast differences in the development of its community geographically and economically. The houses below have been described as homes belonging to J. E. W. Johnson, Charles Phipps, and Charlotte Rhame. As with many homes here, they do not share architectural sameness. They exude an ambience of comfort and closeness to the circles of power. Atlantic Avenue was part of three distinct business areas in the village. Occupants were also close to the seat of power—the village hall and the firehouse. (Courtesy of Rev. Richard Nilsson.)

RESIDENCES ON ATLANTIC AVENUE, East Rockaway, L. I.

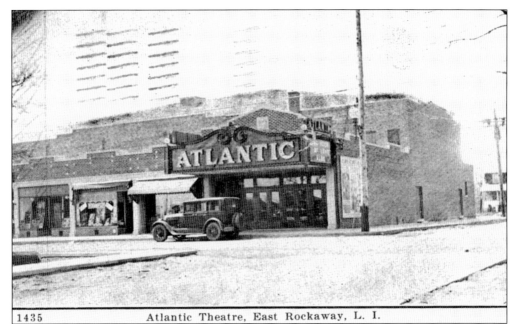

1435 Atlantic Theatre, East Rockaway, L. I.

The Atlantic Theater, an early source of recreation, was located on the corner of Atlantic Avenue and Maxwell Street. It was built by Maxwell Waldowsky, hence the names given for Maxwell Street and Waldo Avenue. Indeed, at one time, movies were filmed on Main Street in East Rockaway. The Criterion replaced it, but today there is no movie theater in East Rockaway. Note that the windows of the Restaurant and Theatre Bar and Grill reflect houses, which stood across the street. Even now, these stores no longer reveal the brickwork of another day. They are covered. Today the Astoria Bank is seen in the same reflection. (Courtesy of Gene Torborg.)

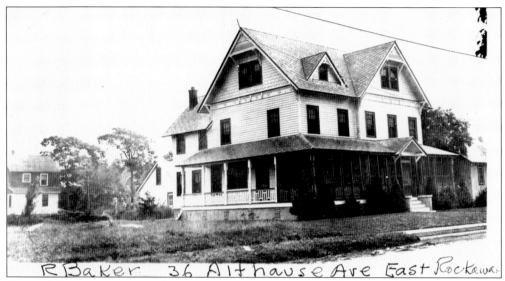

R Baker 36 Althouse Ave East Rockawa.

Robert Baker was president of the board of education in East Rockaway. This was the Stokes house that stood on the present site of the American Legion parking lot. It was moved by the Josef Herman Company, utilizing horses and a Model T truck, from Main Street to its location on Althouse Avenue. Purportedly it was moved because Main Street was too noisy. It was turned around so that the back porch, a large two-story affair, faced north. The wood trim on this house was manufactured at the Davison Lumber Mill. This house has been preserved. (Courtesy of Gene Torborg.)

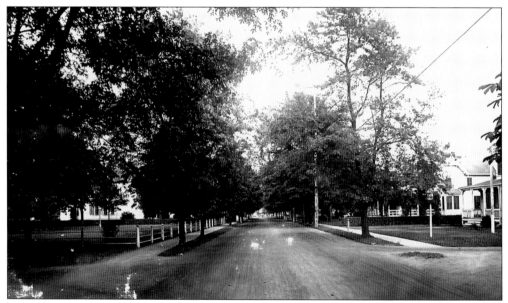

Main Street was lined with trees and no more than 12 houses from present Baiseley Avenue east. West of Baiseley Avenue there were no homes on Main Street, there were only meadows of sweet hay, cranberry bogs, and blackberry bushes. There were two ponds, one near Waldo Avenue and another on the other side of Main Street. In 1900, the population was 969 persons. Stores, restaurants, and most especially hotels emerged to replace the shipping, lumber, and oyster industries. (Courtesy of Gene Torborg.)

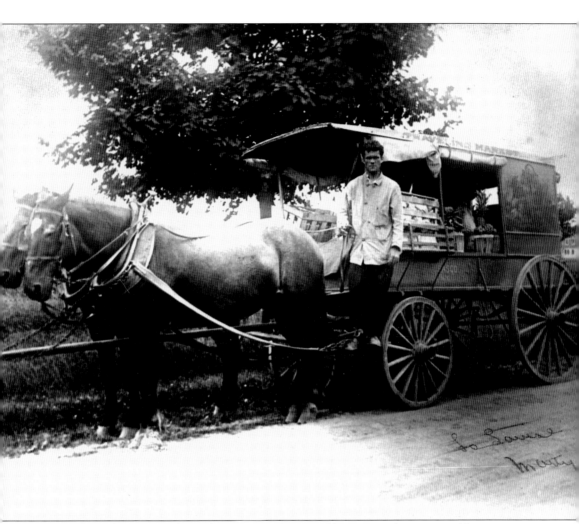

Mario Alti and Company, located at 24 Main Street, sold groceries, fruits, vegetables, premium meat, and frozen goods. It was said that when Alti delivered his goods he would place the groceries in the pantries of his customers. Catherine Lari, daughter of Armando Lari, owner of Lari's Restaurant at 21 Main Street, would accompany her uncle Mario as he delivered groceries when the automobile replaced the horse-drawn wagon. (Courtesy of Catherine Overton.)

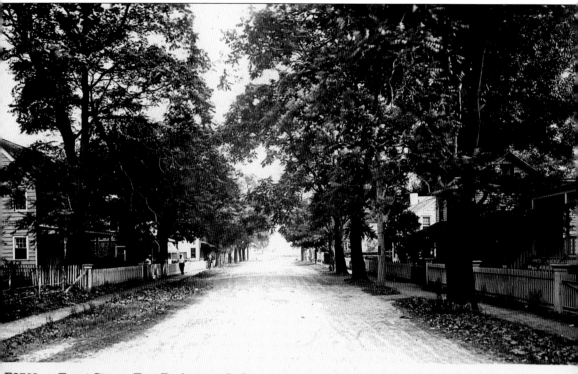

P2763 Front Street, East Rockaway, L. I.

Front Street was a dusty road and had homes that reflected the basic life of the village—hardworking people of modest means. Front Street extended south to Mill River, and hotels, taverns, and boardinghouses were situated there. Interestingly, three of the oldest buildings still standing in East Rockaway are located on Front Street. (Courtesy of Rev. Richard Nilsson.)

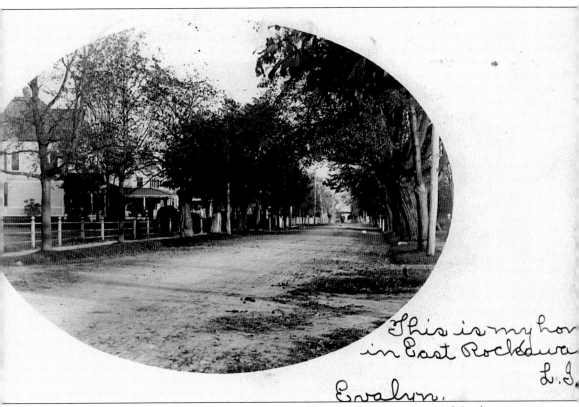

This is my hous
in East Rockaway
L. I.

Evalyn.

Charles W. Davison wrote, "The oyster shell roads of East Rockaway were special. In the spring, when the oystermen would collect their monies from the Davison Mill office safe, they would spread oyster shells on Ocean Avenue. The iron rings of the wagon tires would crush the shells, and by each July, there would be very beautiful white roads." (Courtesy of the Historical Society of East Rockaway and Lynbrook.)

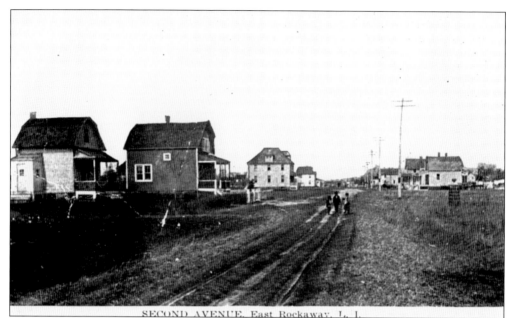

SECOND AVENUE, East Rockaway, L. I.

Second Avenue looking north is pictured in 1916. It is reflective of rustic East Rockaway. The three youngsters trekking up the street are Peggy, Ernest, and Edwin Bishop, whose house is second from the left. They are most likely on their way to Woods Avenue School. Streets were unpaved, often muddy and dusty, and the southern part of the village appears quite treeless. (Courtesy of John Bishop.)

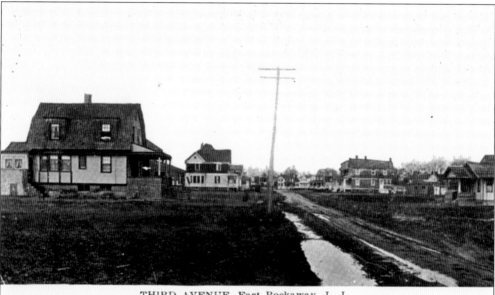

THIRD AVENUE, East Rockaway, L. I.

The similarity of First, Second, and Third Avenues is obvious. These homes, some of which are quite large, do not compare with the stately homes on Main Street and Ocean Avenue. Today there are several new homes built on each of these plots of land, side by side with little land between each house. The roads are paved and treed. These areas were very important to the growth of the village around 1900. (Courtesy of Rev. Richard Nilsson.)

Ten

WATER SCENES

East Rockaway boasted a coastline and beautiful beaches. People enjoyed the water. Everyone knew how to sail, and most people had a rowboat or a sailboat. Most loved to fish. At one time, people in East Rockaway were called "clam diggers" because of the closeness to clam and oyster beds and the jobs they afforded. They provided income, pastimes, food, and pleasure for the people. The equanimity of the pictures makes one reflect with longing on a time when one could lose oneself on the water and enjoy the breezes and scenery. It was said the mosquitoes did not bite the natives; they saved their stingers for tourists. Mosquitoes had been alleged to be a hindrance to the growth of East Rockaway at the dawn of the 20th century. Water was important for East Rockaway too. The Mill River provided power for the gristmill and access to the sea. According to rumors, it was a haven for rumrunners during Prohibition. It is believed by some that a tunnel was built to a number of the so-called establishments and restaurants to accommodate this nefarious trade. It remains part of the aura of the history of East Rockaway. However, it has been most difficult to actually pinpoint the location of that infamous tunnel.

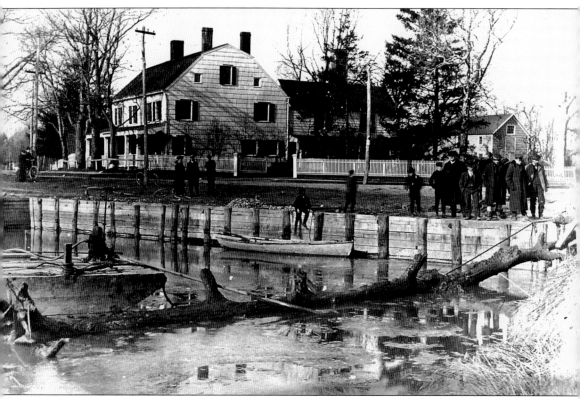

On Thanksgiving in 1903, a perfectly preserved 45-foot red oak tree was dug out of East Rockaway basin. Its branches were trimmed into a 35-foot mainmast flagpole for the post office. The giant of a tree was probably fuel for a Native American oven. It had fallen into the water and remained there. Its bark was green and sappy. It was buried in mud and sand opposite the site of Davison's mill. Charles Davison noted that he never heard his grandfather or father speak of any trees near the water's edge. Pictured among others are Charles L. Phipps; child Charles W. Davison, son of Robert Davison; and "Bob" Brower from Tiger Town, a local house mover. When the engineer of the dredge found that he could neither pierce nor move the obstacle, a house mover was called, and with the help of a derrick and 16 horses, the tree was unearthed. (Courtesy of Gene Torborg.)

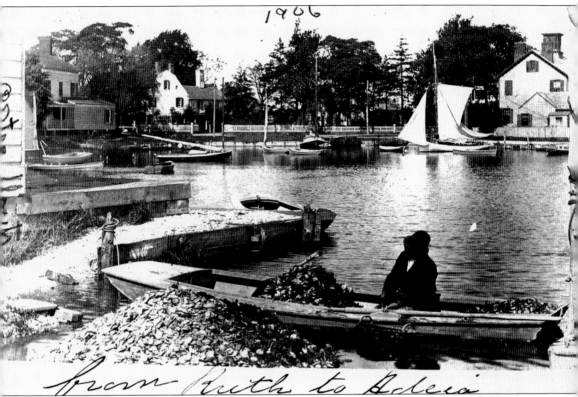

1906

from Ruth to Adele

Oysters provided income, so they were an important commodity. It had been rumored that the Hewlett property and dock were to be sold. Oystermen had used the dock there. It was nearest to the oyster grounds and had the additional advantage of having a stream of fresh upland water to freshen and fatten the oysters. Some of the oystermen were negotiating for the right to land on the property of Oliver Davison and Richard Carman, where they hoped a dock would be built and the creek would be dredged. (Courtesy of the East Rockaway and Lynbrook Historical Society.)

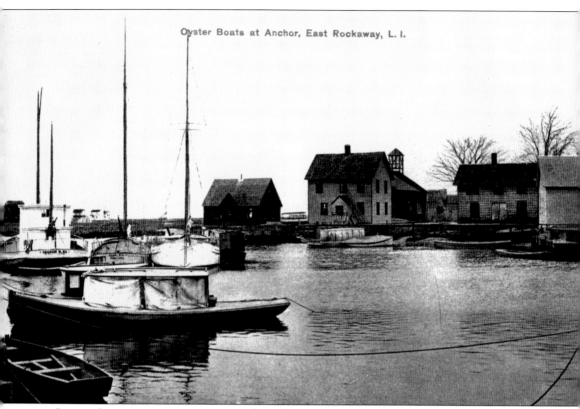

Oyster Boats at Anchor, East Rockaway, L. I.

Oyster planting was an important early industry and source of income for the people of East Rockaway. Oysters were brought in from eastern Long Island and Connecticut and planted in the East Rockaway channel. Maturity could take several years. Robert Davison recalled a family story that oyster planters would deposit their monies in sums as high as $1,000 in the Davison company safe in the fall of the year. There were no banks nearer than Jamaica. In the spring, when it came time to plant oysters, the monies would be rolled and tied with string with the name of the owner on each bundle of bills; there were no rubber bands at that time. The oysters were delivered to oyster floats along the waterfront where they were culled and shipped to city markets. Both oyster shells and clamshells were used to make early roads in East Rockaway. (Courtesy of Rev. Richard Nilsson.)

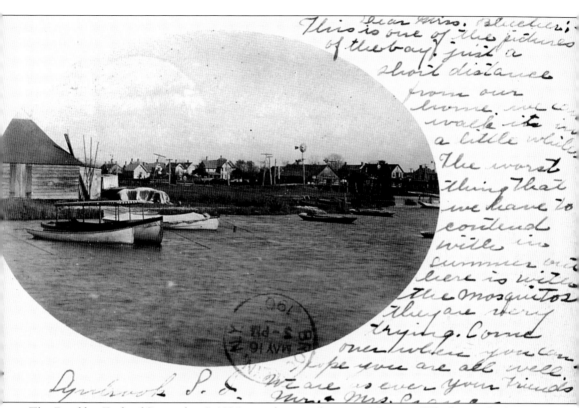

The *Brooklyn Eagle* of September 9, 1894, corroborates this writer's lament. Why have suburban home seekers bypassed such an attractive location like East Rockaway and settled on the inland territory? One reason was the high price at which the land was held. Without any improvement, it was held at $1,000 to $1,500 per acre. Older landowners had been patiently waiting for over a half century for a boom. In addition, it was whispered that the mosquitoes were a constant pain. They never bothered the natives, but they did but make the life of the transient exceedingly active, and their destiny was to make the days of the summer resident a burden. The theory was that they were brought on the southerly winds from the New Jersey lowland. Since no embryo mosquitoes were ever seen in East Rockaway, they must have migrated from some other locality, so New Jersey got the credit for originating them. At one time, there had even been a Nassau County superintendent of the mosquito extermination commission. (Courtesy of the Historical Society of East Rockaway and Lynbrook.)

P2755 Mill River Bend, East Rockaway, L. I.

Mill River and Parsonage Creek are among the names portrayed on the old maps of East Rockaway. East Rockaway residents resisted change for nearly 50 years. Roads remained undeveloped, and large parcels of land were unsold. Longtime families waited for the right price and the right time before they were willing to sacrifice the way it was. Change did come. (Courtesy of the Historical Society of East Rockaway and Lynbrook.)

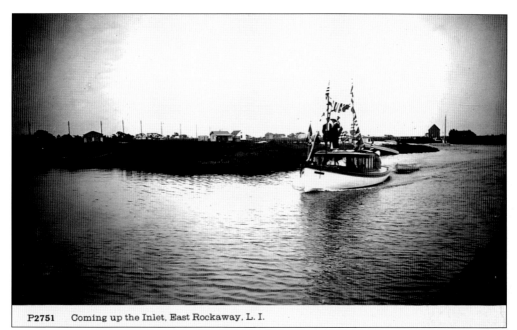

P2751 Coming up the Inlet, East Rockaway, L. I.

East Rockaway was a sportsman's thrill. The ponds were well stocked with smaller fish such as pickerel, white perch, and an occasional bass. Oliver Hewlett caught a 20-pound bass here. An excellent day's sport would be yachting and trawling for bluefish, bonita, and Spanish mackerel. A sail on the ocean to pass a delightful day in August could end with a successful catch of gamey bluefish. (Courtesy of Rev. Richard Nilsson.)

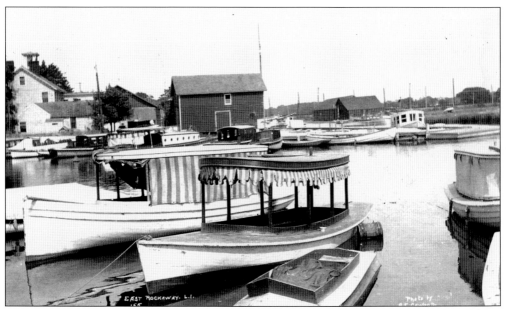

Game fishing, along with good boating, was a great way to pass a day. Quail was plentiful but in jeopardy because sportsmen hunted without regard for the law, which was seldom enforced. Wildlife became scarcer because of the proximity to the city. Rowing and boating parties were one of the social features of East Rockaway during the summer. (Courtesy of Rev. Richard Nilsson.)

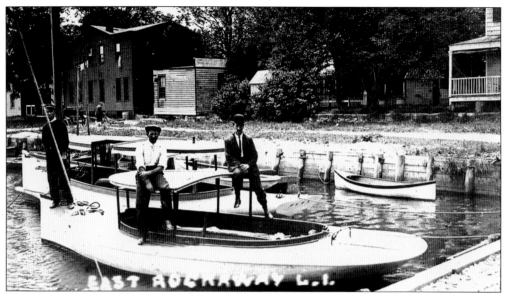

These men appear ready to embark on a small excursion. It is of interest to note that several of the structures in the picture are still standing in East Rockaway. The dusty road is Dock Street. The building to the far left is the Salty Dog, and next is the bait store. The large building behind them is the Mott house, and to the far right is the extinct Sam Rhame store. (Courtesy of Rev. Richard Nilsson.)

East Rockaway Yacht Club, Long Island, N. Y.

The East Rockaway Yacht Club was a home away from home for Oliver Simonson Davison, brother Rusty, and sister Betty. They enjoyed summer living on one of many family boats. Oliver recalled that Betty taught him and Rusty to waltz by the music on the jukebox. Rusty finally learned to swim. He had a tube shaped like a turtle, and siblings threatened to puncture it if he did not swim without it. (Courtesy of Rev. Richard Nilsson.)

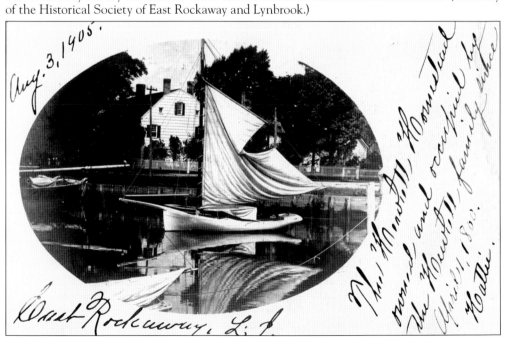

The waterfront of East Rockaway at the beginning of the 20th century was inviting. Many families owned boats and enjoyed water sports and the beach shores. Shipbuilding and racing were also an important part of community life. The waterfront has been preserved. Hattie Hewlett was proud of her heritage, and the Hewlett home was important in East Rockaway history. Hattie was an inveterate writer, and many of the cards that have been preserved with East Rockaway history are because of her communications with friends and relatives. (Courtesy of the Historical Society of East Rockaway and Lynbrook.)

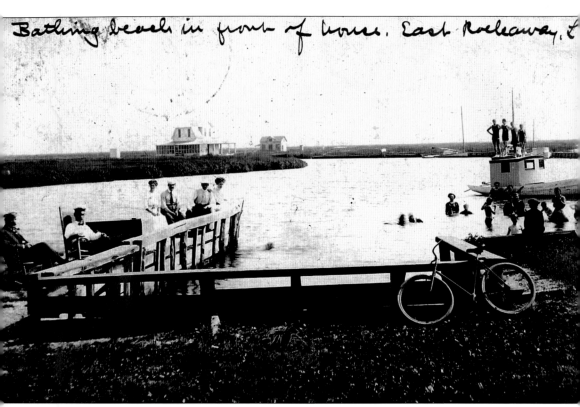

Bathing beach in front of house, East Rockaway, £

The pleasure of swimming near one's home was endemic in East Rockaway. The influence of the ocean was to make the temperature less changeable. The afternoon breezes, which blow with great regularity about noon every day, had proven very acceptable, and the vacationers did not suffer with the heat. Because of the many hotels and boardinghouses, the water provided enjoyment for everyone who came to the shore in the summer. Hotels, boardinghouses, and private homeowners praised these beaches, and they were a selling point in all advertisements for East Rockaway. (Courtesy of the Historical Society of East Rockaway and Lynbrook.)

Relaxation, reading, and rustic surroundings are the epitome of early-20th-century existence in East Rockaway. One can picture the tranquility that exudes from this young woman as she reads her book with little concern for any of life's difficulties. (Courtesy of the Historical Society of East Rockaway and Lynbrook.)

East Rockaway of yesteryear epitomizes the sailing expertise of young and old, the love of life on the water, and the reluctance to welcome the vicissitudes of life. However, modernity cannot be stopped. (Courtesy of the Historical Society of East Rockaway and Lynbrook.)

Across America, People are Discovering Something Wonderful. Their Heritage.

Arcadia Publishing is the leading local history publisher in the United States. With more than 3,000 titles in print and hundreds of new titles released every year, Arcadia has extensive specialized experience chronicling the history of communities and celebrating America's hidden stories, bringing to life the people, places, and events from the past. To discover the history of other communities across the nation, please visit:

www.arcadiapublishing.com

Customized search tools allow you to find regional history books about the town where you grew up, the cities where your friends and family live, the town where your parents met, or even that retirement spot you've been dreaming about.